BEGINNER'S GUIDE TO
FANTASY
DRAWING

BEGINNER'S GUIDE TO

FANTASY

DRAWING

3dtotalPublishing

Correspondence: publishing@3dtotal.com
Website: store.3dtotal.com

First published in the United Kingdom, 2019, by 3dtotal Publishing.

Reprinted in 2023 by 3dtotal Publishing.

Address: 3dtotal.com Ltd, 29 Foregate Street, Worcester, WR1 1DS, United Kingdom.

Soft cover ISBN: 978-1-909414-92-1

Printing and binding: Dongguan Everbright printing co., ltd (china) www.everbrightprint.com

Visit store.3dtotal.com for a complete list of available book titles.

Managing Director: Tom Greenway
Studio Manager: Simon Morse
Assistant Manager: Melanie Robinson
Lead Designer: Imogen Williams
Publishing Manager: Jenny Fox-Proverbs
Editor: Marisa Lewis
Designer: Joseph Cartwright

Front cover artwork © Martin J. Abel
Back cover artwork © Roma Gewska
Belladona font © Tano Veron

50%
of net profits donated
TO CHARITY

In 2022, 3dtotal Publishing became successful enough to make a pledge to donate **50% of its net profits to charity**. This continues to be possible due to the incredible support from all our customers, employees, and partners. At the time of printing, we have donated over $1.3 million (USD) to charity.

We focus our giving on three charitable areas: **environmental, humanitarian, and animal welfare**. We use organizations such as Effective Altruism and Founders Pledge to guide who we help within these causes. Some ways of doing good are over 100 times more effective than others, so donating this way hugely increases the impact of our contributions.

See 3dtotal.com/charity
for full details.

Image © Martin J. Abel

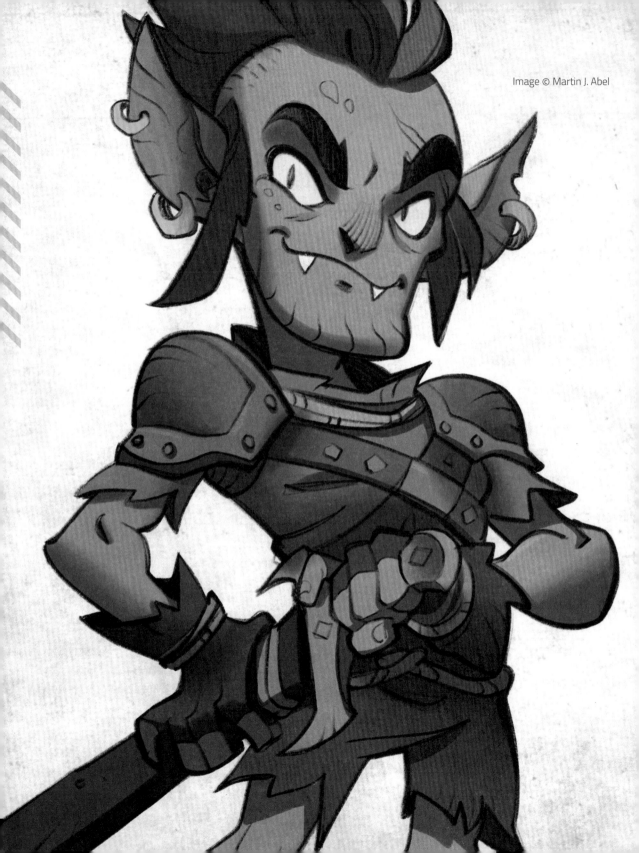

CONTENTS

INTRODUCTION 8

GETTING STARTED 10

Tools and techniques 12
Drawing tools 14
Pencil techniques 16
Pen techniques 18
Color theory 20
Color symbolism 22
Adding color 24

Anatomy 26
Body basics 28
Heads and faces 32
Exaggeration 36
Hands 38
Expressions 40
Animals 42

Design techniques 44
Foreshortening 46
Poses 48
Lighting 52
Design variations 54

Process tips 56
Drawing habits 58
Research 60
Thumbnails 62
Storytelling 64
Motivation 64

TUTORIALS 66

CHARACTER LINE-UP 68
KNIGHT 70
ROGUE 80
MAGE 90
BARD 100
RANGER 110

CREATURE LINE-UP 120
DRAGON 122
UNICORN 132
FAERIE 142
GRIFFIN 152
ORC 162

PROJECT BRIEFS 172
GLOSSARY 174
CONTRIBUTORS 176

INTRODUCTION

The fantasy genre has captured people's hearts and minds for what seems like forever. Fantasy books, movies, cartoons, and games, from *The Lord of the Rings* to *The Legend of Zelda*, are often what inspire budding artists of every age to try drawing for the first time.

Drawing can often be a challenge, though, especially when your imagination is alight with fantastical ideas. It can be difficult to know where to begin or what to do next, and it's easy to lose your motivation in the early stages of learning to draw.

In *Beginner's Guide to Fantasy Drawing*, a team of talented artists from around the world and all over the creative industries will guide you through crafting fantasy concepts. The "Getting Started" section of the book will introduce you to the important skills and foundations that you should try to make a part of your regular drawing practice. The "Tutorials" section will show you how to apply that knowledge to a range of projects with different subjects and styles, packed with other artists' tips and advice for you to experiment with.

Practice the exercises and techniques shown in this book, and you'll come away with the skills you need to fill your own fantasy worlds with exciting inhabitants. Pick up your pencils and let's get started!

Marisa Lewis | Editor

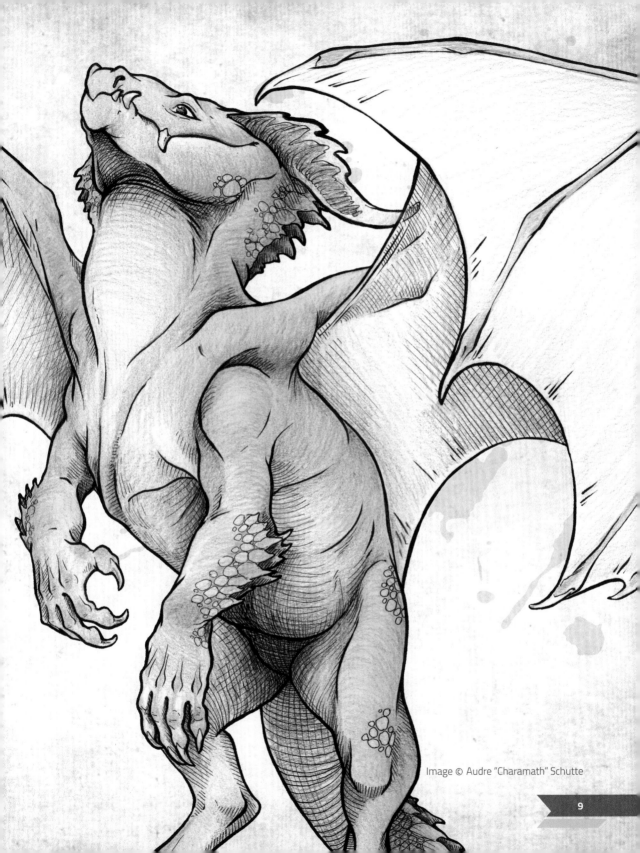

GETTING STARTED

Before you jump into creating any brave warriors and mythical creatures, it's important to know some basics. What equipment will you need for your fantasy art adventure? What are some good drawing habits to practice and useful anatomy basics to know? How do you capture the personality of a character and present them in an exciting way? This chapter is split into four sections that will help to prepare you for this book's tutorials and creating your own fantasy designs.

⊙ TOOLS AND TECHNIQUES

General knowledge about drawing tools and shading techniques is invaluable for any subject matter. This section covers commonplace drawing tools and how to use them, as well as coloring basics.

⊙ ANATOMY

This section will give you a fun overview of drawing human figures, from the full body to hands and faces, as well as a few key animals which will serve as the basis for some magical monsters later in the book.

⊙ DESIGN TECHNIQUES

Part of creating a memorable design is adding action, personality, an exciting composition, and features that tell a unique story about your character. This section will teach you more about how to achieve these goals.

⊙ PROCESS TIPS

This section offers an experienced artist's perspective on how to stay creative, motivated, inspired, and get the best drawings out of your ideas – useful wisdom which you can take forward in this book and beyond.

Image © Roma Gewska (See page 80)

TOOLS AND TECHNIQUES

BY MARTIN J. ABEL

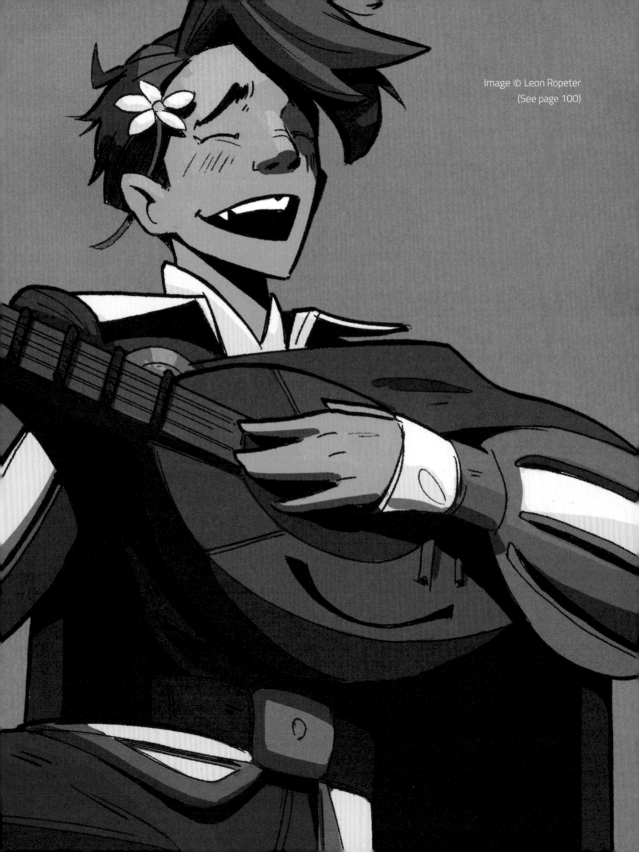

DRAWING TOOLS

Getting started with drawing does not require many tools, and they do not have to be expensive or complicated. All the tutorials in this book can be followed with pencils, pens, and colored markers or colored pencils. Let's begin by looking at these tools and some of the many ways they can be used.

WOOD PENCIL

MECHANICAL PENCIL

⊙ PENCILS

⊙ **Regular wood pencils** in grade HB are a good starting point. I personally use a regular pencil in grade F, which allows me to draw light, rough lines, and if I need to make bolder lines, I use a 2B, which is slightly darker.

⊙ **Mechanical pencils** are a great option because they require no sharpening and always produce a consistent, solid line.

⊙ **Colored pencils** are a great tool for finishing a drawing, and can be found in a huge range of colors, as well as erasable and water-soluble types.

PENCIL GRADES

There is a scale to determine the darkness and hardness of a pencil's core, which ranges from 9H (very hard and light), to F and HB (a versatile middle ground), through to 8B (very soft and dark). Start with whatever you can find, and then experiment!

⊙ PAPER

Choosing a paper that you feel comfortable drawing on is a very important aspect of becoming an accomplished artist. It takes a while to find the paper that you prefer; some people prefer rough **textured paper**, and others prefer very **smooth paper**. There is no right or wrong paper preference, though some types of paper are more suited to a particular tool than others.

You can work on **individual sheets** or in a **sketchbook**. Sketchbooks come in lots of different varieties, such as with spiral or stitched binding. I personally love smaller sketchbooks, as they are easy to take anywhere.

SKETCH BOOK

PENS

Fineliner pens give you a lot of control over inking your drawings. They come in a variety of nib sizes for making thick or thin lines.

Brush pens usually have either a flexible felt tip or actual bristles similar to a paintbrush. They are much harder to control and definitely give you a unique style of line. You can create a line that changes thickness depending on how hard you press on the paper, which is a great way of creating varied line widths and conveying perspective.

Ballpoint pens are sometimes all you have handy – I used to always draw with them at school! These pens are fun because you can use them very lightly to sketch and render with but also press hard to achieve bold, clean lines.

FINELINERS

MULTILINER SP 0.3

MULTILINER SP 0.1

BALLPOINT

BRUSH PEN

MARKERS

Stationery markers like Sharpies are generally not blendable, but are affordably priced and work well if you want to add solid, vibrant color.

Alcohol-based markers, such as Copic markers, usually have a brush tip and a chisel tip on either end, which allow for different types of mark-making. These markers are made to be blended, so when you color over the top of another color, the layers will start to change and blend. You can achieve some amazing effects with these – I highly encourage you to try brush markers.

Coloring with markers is a great way to finish your drawing, so try to experiment with some different types and brands.

SHARPIE MARKER

COPIC MARKER

PLASTIC ERASER

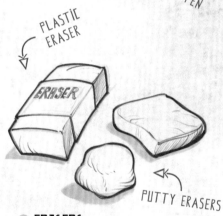

PUTTY ERASERS

ERASERS

A regular **plastic eraser** is usually sufficient to start with, but you might consider looking at some of the other options out there.

One of these options is the **kneadable or putty eraser**, which you can mold into a ball or any shape. This allows you to control how firmly or lightly you erase your drawing, and the putty does not leave rubbings like a plastic eraser.

PENCIL TECHNIQUES

The pencil is one of the most essential tools in your kit. It is versatile, forgiving, and can be taken anywhere! Here are some key ideas and techniques to try when working with pencil.

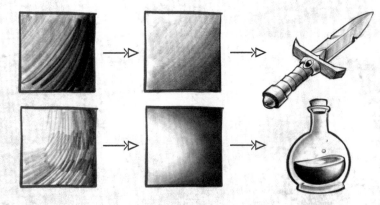

THICK, HEAVY LINES

LIGHT, THIN LINES

⊙ VARIED LINE WEIGHTS

Varying the weight of your pencil lines by changing pressure and angle is useful for a variety of things. Most importantly, sketching softly allows you to erase more easily and ensure your drawings do not get too messy. Draw your rough sketch very lightly, and then when you are happy with its direction, go over it again and reinforce those good lines with a heavier line weight.

⊙ SOFT SHADING

You can render your pencil or pen drawings with pencil shading, creating soft and subtle effects. It helps to use the overhand grip (page 58) to shade with the side of the pencil instead of the tip, as this will allow you to cover a wider area and blend more easily. You can use your fingertip or a paper stump to smudge the pencil and create even smoother blending.

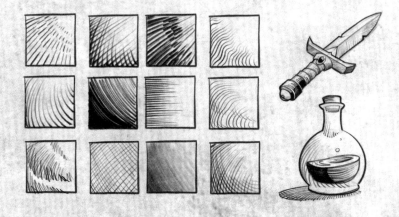

⊙ HATCHED TEXTURES

If you prefer to stick with lines for shading, **hatching** might be for you. This type of rendering is achieved by just using lines in a combination of directions (sometimes layered in opposite directions to create **cross-hatching**). There are many ways to create a hatched texture, and you can imply many different surfaces just by using a different shape of line or pattern of lines.

ERASING HIGHLIGHTS

Erasing is not just for when you make a mistake. When you are shading with pencil, erasing can become a valuable trick to have up your sleeve. By erasing only certain sections of a shaded area, you can create the shine on an apple, or the highlights and reflections on a glass bottle.

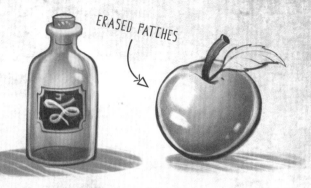

ERASED PATCHES

COLORED UNDERDRAWING

Try sketching first with a **colored pencil**, and then refining the drawing with a regular pencil or going straight to inking (adding ink lines with a pen). If you are able to edit your images on a computer, the great advantage of this approach is that the colored sketch is easy to isolate and erase digitally, leaving behind only the final pencil or ink lines. This is extremely useful when you want to clean up and color a drawing for a final project.

QUICK SKETCHING

Sketching quickly is useful for getting down a rough idea without overthinking it or getting stuck on details. It's all right if it does not look perfect, or is not fully detailed – the aim is to establish an idea to expand upon later. Try making quick multiple drawings of the same subject until you find the best way to tackle it.

PEN TECHNIQUES

Working with pen is a bigger challenge than working with pencil, but being brave enough to commit ink to paper can really help your artistic confidence and bring a higher level of polish to your drawings.

◎ NIB SIZES

Fineliner pens come in a variety of nib sizes, from the tiny 0.05 mm to the large 0.8 mm, enabling you to create thin or thick lines. There is no point scratching away with a tiny nib when you are trying to create really thick lines – that's just too much effort! Grab a pen with a bigger nib instead. It is equally difficult to create intricate little details with a large nib, so make sure you always have a variety of pens on hand.

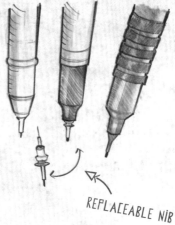

REPLACEABLE NIB

◎ FINELINER DRAWING

Inking your sketch with fineliner pens is a skill that takes time, and you can tackle it in a variety of ways. You could use the same nib size, for example, or experiment with using a thicker nib for your character's outlines to make them stand out.

I like to use fine lines for details and heavier lines for the outlines. Sometimes I double back on those lines to thicken them and make them flow more.

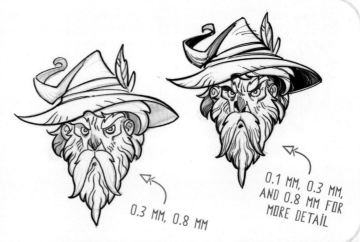

0.3 MM, 0.8 MM

0.1 MM, 0.3 MM, AND 0.8 MM FOR MORE DETAIL

◎ BALLPOINT SKETCHING

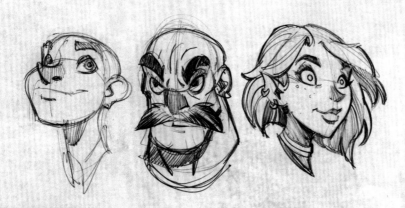

Use a ballpoint pen lightly to create softer, sketchy lines for your base drawing, and then press a bit harder to get your "real" lines down. You can add shading like this, too. Ballpoint pens are a great tool to master because they are so common, and sketching with them is a fun way to get used to drawing with a permanent ink medium.

◉ FINELINER HATCHING

Hatching with a fineliner follows the same principle as hatching with a pencil: lines repeating in a straight or curved direction, followed by more lines on top going in another direction to create shadow and depth.

You can make repeating patterns and play around with different line thicknesses to create a range of interesting textures and lighting effects.

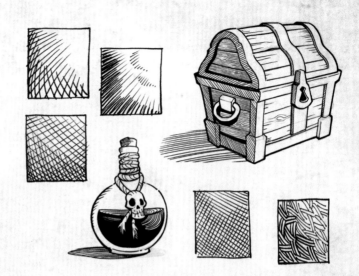

◉ BRUSH PEN STROKES

The brush pen is a tricky tool to master. If you are trying to create perfect lines, you may not be happy using one at first, because they offer much less control.

The brush enables you to create a line that changes from thin to thick, just by applying more or less pressure when you draw on the page. This is why you have to develop a very steady hand to create something neat. However, if your style is messy and chaotic, this could be the tool for you!

One advantage of the brush pen is that, once you get the hang of creating line weights with it, it can be quicker than inking with fineliners.

◉ SOLID BLACK AREAS

The brush pen is also very handy for filling in large areas of solid black that would take you a lot longer to fill with a fineliner pen. This is useful for speeding up inking, and also for your drawing stamina.

COLOR THEORY

Colors add extra life and story to your designs, and can be added with only a few simple tools. If you do not have a full range of colors available, even a limited palette can be very effective. We will look at some commonly used coloring tools and useful color-related ideas here.

○ COLOR WHEEL

To remind yourself of certain color theories, and how to mix colors and what kind of colors you may want to use, a simple color wheel is very useful. This example is a simple six-part wheel, but you can find many different types online or in reference books. On this color wheel you will find all the warm colors on one side (red, orange, and yellow), and the cool colors directly opposite (blue, green, and purple). Color theory is an in-depth topic, but in brief, colors convey certain emotions and moods, and have a huge impact on your final artwork.

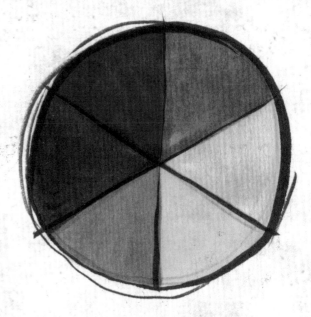

PRIMARY COLORS are red, yellow, and blue. These colors cannot be created by the combination of any others, but all other colors are made by these special hues.

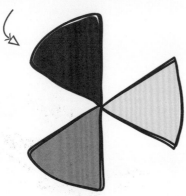

SECONDARY COLORS are green, orange, and purple. These are all created by mixing two primary colors together.

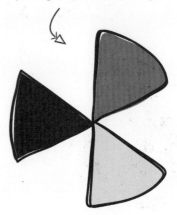

⊙ COMPLEMENTARY COLORS

Complementary colors are colors that are directly or almost directly opposite each other on the color wheel, such as green and red. These combinations will always go well with each other, but also have a high contrast that creates a dramatic impact on the viewer.

⊙ ANALOGOUS COLORS

Analogous colors are hues that are next to each other on the color wheel, such as blue and purple. Choosing these colors can give your artwork a softer feel and be pleasing to the eye, even though they might seem less dramatic than complementary colors.

COLOR SYMBOLISM

Colors can be used to evoke certain moods, emotions, and associations for the viewer. When creating an image, it helps to know what colors can mean, so you can choose the ideal palette. There are more colors than we can possibly fit onto these pages, and the symbolism of colors can change in different contexts and cultures, but these suggestions are a good place to begin your research!

⊙ RED

Red is a powerful, intense color that is often associated with passion, anger, and danger.

⊙ BLUE

Depending on the shade, blue's meanings can range from calming and serene, to icy and melancholy.

⊙ YELLOW

Yellow is a bright, friendly color associated with sunshine and positivity.

⊙ GREEN

Green is the lush hue of plants and nature, but can also be an envious or poisonous color!

◉ PURPLE

Purple is quite a magical, mysterious, and decadent color, associated with wealth, luxury, and creativity.

◉ ORANGE

Like red and yellow, orange is a vibrant color associated with sunshine, warmth, and vigour.

◉ BLACK AND WHITE

Black is often associated with darkness, death, and mourning, while white is a traditional symbol of purity in some cultures. Gray can be seen as neutral, formal, or drab.

◉ BROWN

Brown is the color of soil and wood – a neutral, earthy color associated with nature and plain, simple things.

PLAYING WITH COLORS

Try applying different colors to the same design to see just how powerful they can be for changing personality and mood. Don't feel limited by classic color archetypes, though - you can subvert viewers' expectations of a character's personality with color too!

ADDING COLOR

◉ COLORED PENCILS

Coloring your drawings with colored pencils is a skill that takes a lot of practice, and having good quality paper and pencils is essential to getting a strong end result. The great thing about coloring this way is that you can blend colors together by lightly shading over the top of another color. Try using two or more colors to practice making gradients that shift from one hue to another, like these examples.

◉ COLORED MARKERS

Using alcohol-based markers to color your drawings is an exciting thing to learn. These markers are made for blending together, especially the ones with both a chisel tip and a brush tip. This brush tip can produce results almost like painting, as you can see in the process below. As markers are a translucent medium that can be layered, start from the lightest color before adding more layers or darker hues.

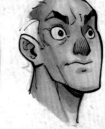

BLENDING LIGHT AND DARK

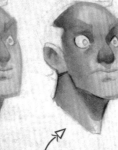

START WITH LIGHTEST HUE

BUILD UP LAYERS FOR SHADOWS

◉ LIMITED PALETTE

It can be expensive to get a full set of pencils or markers, so sometimes you have to work with what is available. Thankfully, you can still create some great drawings even with a limited color range. For example, using only gray markers, and one accent color for special areas, is a satisfying way to create with a limited color palette.

◎ WATERCOLORS

A starter kit of watercolors is an affordable option for adding colors to your images. Like markers, they are a translucent medium that can be built up in layers, but can be more challenging to control and require thicker paper. Check out page 119 to see how watercolors can be applied to a concept!

TRAVEL PALETTE AND WATERBRUSH

BY MARTIN J. ABEL

Image © Valentina Remenar
(See page 90)

BODY BASICS

Now that you have your tools ready, we will look at some of the key knowledge you will need before making your own fantasy designs. Let's start with some of the core body types you can use as a basis for characters of any shape, size, and age. These turnaround drawings can help you to learn the general proportions for different types of human bodies.

ANY FIGURE CAN BE SIMPLIFIED INTO BASIC SHAPES

TURN TO PAGE 48 TO READ ABOUT CREATING POSES

BASIC SHAPES

It helps to break down each part of the human body into basic shapes to depict its general proportions and perspectives. Drawing shapes such as a sphere for the head, cylinders for arms, and circles for joints, and knowing the general proportions and where things line up, will greatly help you to draw the human body.

It's not essential to draw like this in detail – you can just create "gesture drawings" which focus on capturing only the essential shapes and pose of the figure. Use quick lines with a "line of action" and a shape here and there to suggest the forms. However, it still helps to practice these techniques because you will build a library of knowledge that you can use in the future.

LINE OF ACTION

Drawing a strong "line of action" down the figure's spine (shown in purple on these pages) will help you to draw the body with a flowing or dramatic pose. When viewed from the side, the human spine should be curved, not straight!

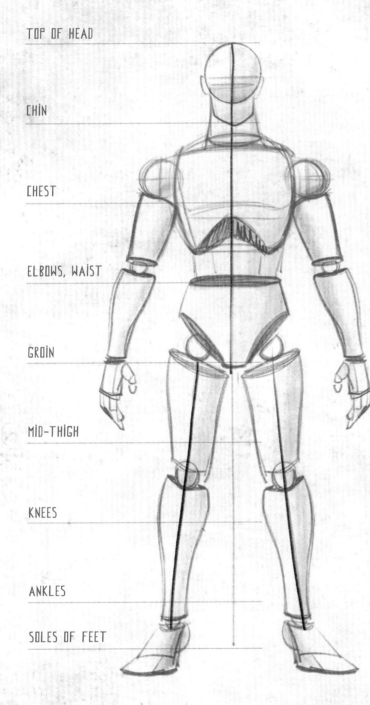

TOP OF HEAD

CHIN

CHEST

ELBOWS, WAIST

GROIN

MID-THIGH

KNEES

ANKLES

SOLES OF FEET

MEASURE WITH HEADS

A common approach to working out human proportions is measuring the body in "heads," or units equivalent to the length of the figure's head from top to chin.

An average adult figure may be seven or seven-and-a-half heads tall (pictured left), but in art, a figure may be eight heads tall for more epic "superhero" proportions.

Measuring in heads makes it easier to map out the proportions and major landmarks of the body indicated on the left. By adding line art and surface details such as hints of muscle and bone structure, you can flesh out basic geometry into a recognizable character.

CIRCLES FOR JOINTS

CYLINDERS FOR LIMBS

PRIMITIVE SHAPES

Practice drawing and shading "primitive" geometry – the most basic shapes such as spheres, cubes, cylinders, and cones. These will help you to visualize three-dimensional objects, and you can combine different shapes to achieve more complex structures.

EIGHT HEADS HIGH

ANGULAR SHAPES

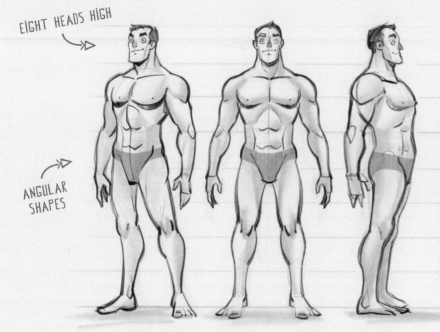

◉ ARCHETYPAL MALE FIGURE

For general proportions, an adult human should be seven to eight "heads" in height, as shown on these pages. This adult male figure has an archetypal heroic physique, standing eight heads tall. Other important key elements are broad shoulders, a square jaw, and a torso and hips that are fairly straight and flat.

SOFT, CURVED SHAPES

WIDE HIPS

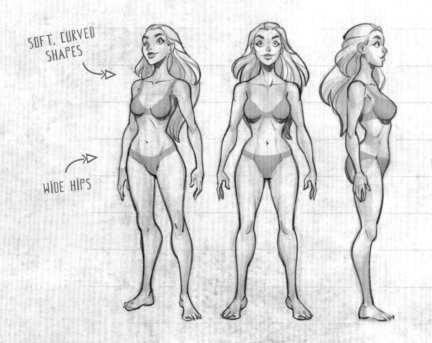

◉ ARCHETYPAL FEMALE FIGURE

The female figure will generally have soft curves, small or narrow shoulders, a slim neck, and a typical "hourglass" figure where the waist gets thinner towards the middle and rounds out at the chest and hips. Note that this character is also eight heads high, for a classical athletic proportion.

HEAD IS PROPORTIONALLY LARGER

SHORTER IN STATURE

⊙ TEENAGER

For teenagers and younger adults, you can play around with the proportions to create a more youthful appearance. A lot of depicting a teenager will come from the attitude of their pose, but we can still establish a lot through the design of the figure. Giving this younger female character smaller hips, a smaller chest, and a shorter height (seven heads) is a good start.

LARGE HEAD AND FACIAL FEATURES

ONLY FOUR HEADS HIGH

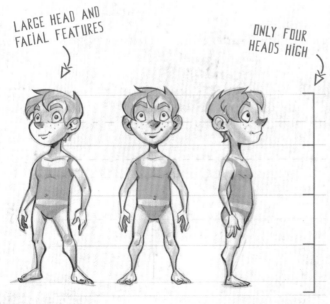

⊙ CHILD

Drawing a child can be done in various ways and really depends on the age you are trying to convey. This character could be about seven years old, so make his head large in comparison to his body, and make him only four heads tall instead of the usual seven or eight. As a rule of thumb, the younger the character, the larger the head, and the smaller the body and limbs.

HEADS AND FACES

The human head is full of intricacies that can make it daunting to draw, but as we have seen already, there is no part of the body that cannot be simplified into basic shapes. Here we will explore and compare some different heads and see how easily they can be constructed.

☉ MALE HEAD

The human head can be simplified into a few basic shapes, starting with the sphere of the skull, with dividing lines in the center going horizontally and vertically. The brow rests on the horizontal line. A short distance underneath this is another line indicating where the eyes should go. Underneath this, we can block in a general shape for the cheekbones all the way down to the jaw and chin. As a loose rule, the line for the nose falls halfway between the eye-line and the chin, and the line for the mouth is halfway between those. Generically, most males will have a strong brow, jaw, and wide chin.

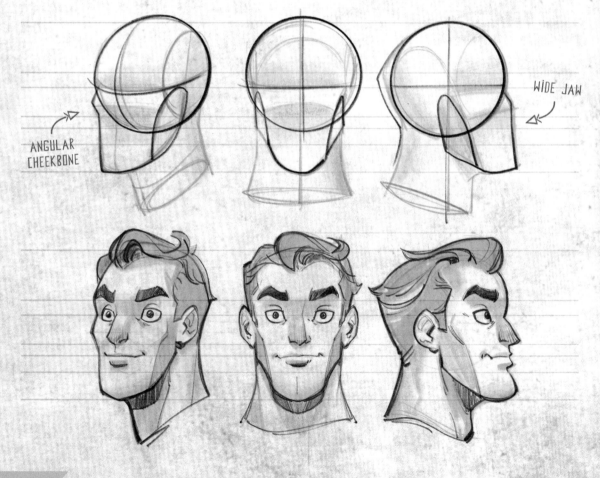

ANGULAR CHEEKBONE

WIDE JAW

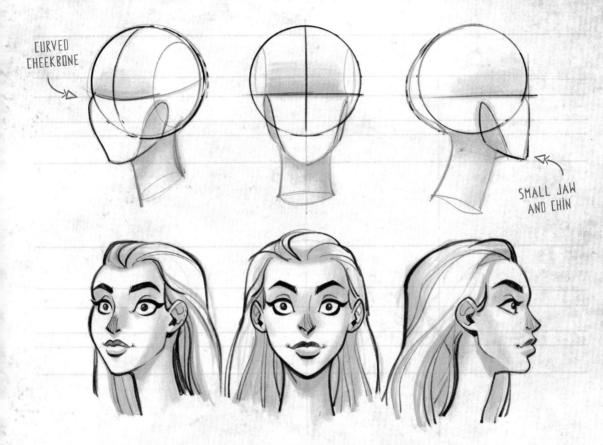

CURVED CHEEKBONE

SMALL JAW AND CHIN

PROPORTION TIPS

////////////////////////

It is helpful to look at references to check how features line up with each other. For example, the bottom of the ear will line up with the nose or mouth, and the eyes are usually one eye's width apart.

◉ FEMALE HEAD

Drawing the female head uses exactly the same concept of shapes and measurements as the male head, with vertical and horizontal lines dividing a sphere. Creating female faces also follows the same theory as female bodies, consisting of smooth curved forms, and small brow, jaw, and chin. Note how the eyebrows are thinner than those on the male face.

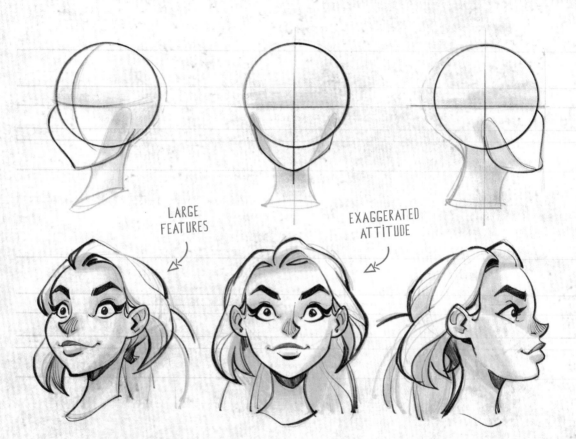

LARGE FEATURES

EXAGGERATED ATTITUDE

◉ TEENAGE HEAD

One way of drawing a teenager's face is to give them bigger eyes, a smaller nose, and larger forehead. The physical differences are subtle, but a lot of it comes down to character expression and style.

PROPORTION TIPS

The larger you make a character's eyes, the more childlike and innocent they will appear. Smaller eyes will make the face look more mature, as you can see on the previous pages.

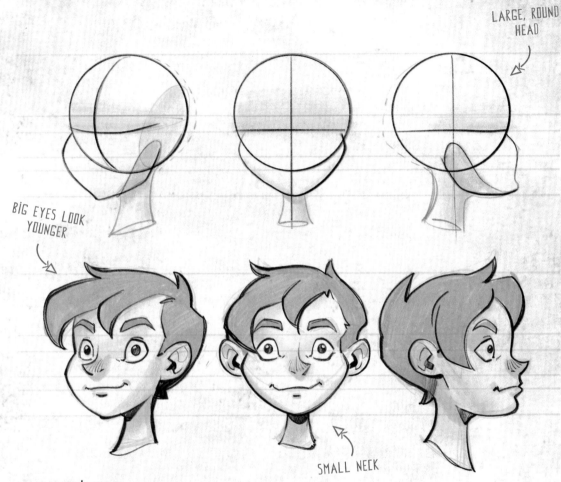

LARGE, ROUND
HEAD

BIG EYES LOOK
YOUNGER

SMALL NECK

⊙ CHILD'S HEAD

A child's head is large and bulbous,
and you can have fun with how big you
want to go, depending on the style and
age you are aiming for. Exaggerate this
effect by making the ears large and the
neck thin in proportion to the head.

EXAGGERATION

Once you understand the basic structure of the body, you can start to create variety in your characters' body types by changing their proportions. Exaggerating a figure's stylization and shapes is also useful for quickly communicating a character's role and personality to the viewer.

POINTED FEATURES

LONG, THIN LIMBS

⊙ STRONG AND HEROIC

You can create a strong, physically powerful character by exaggerating the muscles and the frame of the body. To convey this body type, enlarge the size of the character's chest, shoulders, neck, and leg muscles.

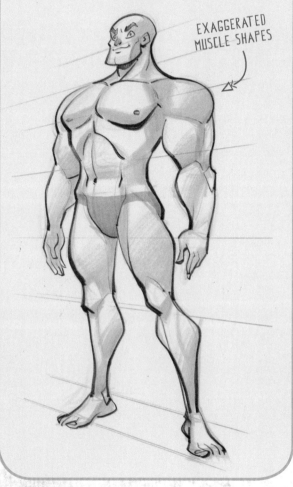

EXAGGERATED MUSCLE SHAPES

⊙ TALL AND VILLAINOUS

You might want to make a tall, thin, scary wizard, and for this body type you need to thin him out in those same places that we exaggerated the strong and heroic figure. Keep in mind that drawing a character with their chest puffed up and out is always a good way to show confidence and power.

⊙ WIDE AND HEAVYSET

To make a stocky character such as this dwarf, try exaggerating how big and wide the torso is compared to the legs. If the character is more chunky than muscular, make sure to draw fewer lines where the muscles would be, and focus more on the figure's overall mass than on muscle details.

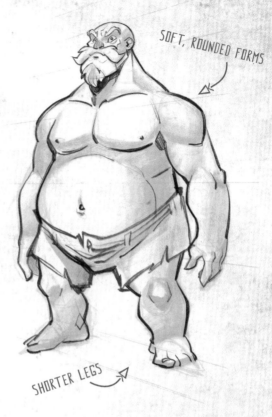

SOFT, ROUNDED FORMS

SHORTER LEGS

⊙ ELDERLY AND FRAIL

Drawing elderly and frail people is fun because you can exaggerate the body in different ways. One possible approach is to give the character a hunched back, pushing their head and neck forward, and making their belly stick out a bit too.

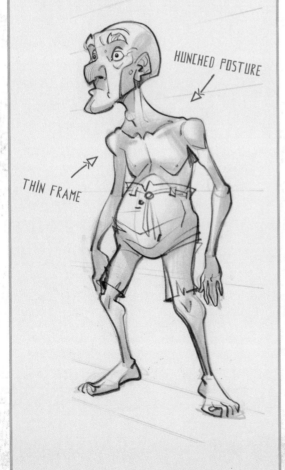

HUNCHED POSTURE

THIN FRAME

SHAPE LANGUAGE

"Shape language" refers to how different shapes create moods and associations. A character with soft, rounded shapes looks friendly. Spiky, angular shapes can look dangerous. Wide, square shapes look strong and solid. Think about how the shape language you choose can enhance your character's personality traits and tell a story.

HANDS

Hands are an especially tricky part of the body to draw, but are essential for creating expressive characters and dynamic poses. Luckily, the complex structure of the hand and fingers can be simplified into shapes that are much easier to grasp – no pun intended!

◉ BACK OF THE HAND

The back of the hand is very similar to the front, but it is important to know where those knuckles go, and how all the parts connect. The knuckles are almost diamond-shaped, but this changes depending on how the hand is flexed. Be sure to reference your own hands and study how they work, as they are your best source of reference.

◉ OPEN HAND

Like the rest of the body, breaking down the hands into their simplest shapes will help you learn how they work and how to draw them. The fingers can be simplified into three cylinders, and the palm of the hand into another three sections as shown below. The thumb also has three parts, including the round palm section and curved tip. Keep in mind that the fingers don't all match up at the top! In general, the pinky will be the smallest, the index and ring finger will be about the same length, and the middle finger will be the longest.

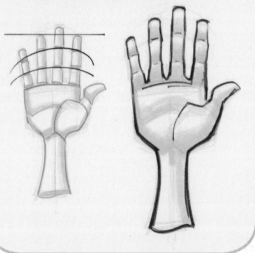

"U" SHAPE

◉ CLOSED FIST

When drawing the hand in different positions, even as a closed fist, it is essential to know where the fingers go and how they fold. With a closed fist, the three cylinders of the fingers almost create a "U" shape. Try making a fist and having a look for yourself.

DRAMATIC HANDS

Once you have practiced and have an understanding of the core shapes of the hand, you can try putting them into dramatic gestures such as these. To create a convincing hand position like this, you can see how using simple cylinders is very helpful to figure out the placement of each finger.

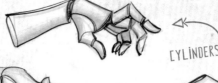

CYLINDERS FOR FINGERS

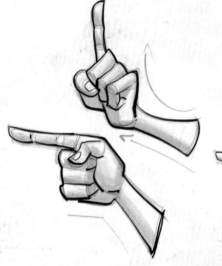

POINTING HANDS

Pointing hands can be expressed in a variety of ways, and once you are confident with your shapes, you can exaggerate the poses even further. Here I have added some direction lines to help illustrate the flow of these poses. People may not naturally point like this, but the exaggerations add so much character and convey the action clearly. Try the hand positions yourself to see!

HOLDING A WEAPON

A hand holding a weapon is much like the closed fist, except you have to remember that the hilt of the sword or staff will have to fit underneath those fingers. It is always fun to add expression too – instead of all the fingers lining up perfectly, pop out the index finger or pinky a little, to add some flare and movement.

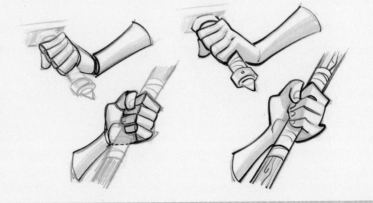

EXPRESSIONS

The face is often the most intriguing and relatable part of a character. A fearsome scowl or villainous sneer can tell a story about your character and make a drawing complete. Let's explore some examples of useful facial expressions in this section, and on page 48 you'll find ideas for poses for the whole body. Imagine all the potential combinations!

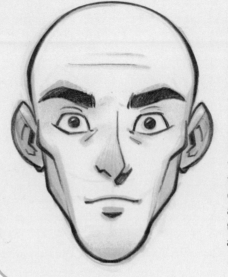

⊙ NEUTRAL

When creating expressions, it is helpful to know how and why we manipulate the parts of the face we do to convey certain emotions. Key parts of the face we want to manipulate are the eyes, brows, mouth, cheeks, and eyelids. In a neutral expression, all those features are even and relaxed.

SCOWLING BROWS

BARED TEETH

CHEEKS PUSH UP EYELIDS

MOUTH CREATES DIMPLES

⊙ ANGRY

Pushing the eyebrows down is the most obvious way to create an angry face, but combining them with squinting eyes, flared nostrils, and gritted teeth can push the expression much further.

⊙ HAPPY

There is more to a happy expression than just a curved line for a smile. The cheeks will rise, sometimes creating dimples, and react with the bottom lids of the eyes, changing their shape too.

◎ SCARED

Raise the eyebrows and make the eyes really wide and round to create a shocked or scared look. The character's pupils may shrink, and the mouth can drop open in fear or surprise.

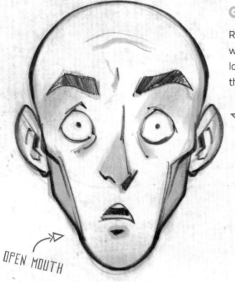

WIDE EYES

CREASED BROW

OPEN MOUTH

◎ SAD

A sad face is not simply an upside-down smile, as some people might draw it! The eyelids, and more importantly the eyebrows, lift up in the middle, creasing the brow. This can also indicate worry or nervousness.

DOWNTURNED MOUTH

NARROWED EYES

MIX IT UP

Try mixing and matching aspects of all of these, and you will find that just adding a little smile to one of them can convey a completely new emotion! There are so many expressions that we all make on a daily basis; these are just a start.

◎ SNEERING

Similar to an angry expression, you can create a sneer by lowering the eyebrows, squinting the eyes, and drawing a crooked, quick, nasty smile. These combined qualities can make a character look cruel, smug, and cunning.

CROOKED SMIRK

ANIMALS

Later on in this book we will be concocting some hybrid fantasy creatures, but before we can draw any dragons, griffins, and unicorns, it is important to understand how real animals are constructed.

HIDDEN WING JOINT

⊙ EAGLE

Eagles are constructed with a small circle for the head, with a beak shape attached; a long, large cylinder for the neck; and a large elongated sphere for the body. The tail is a flat fan shape, and the legs have large thighs. It helps to research the anatomy of the wings to be able to depict them correctly. Use small circles to indicate the joints that are hidden from our view, as knowing how they move and contract will help you understand how to draw them. The feathers are also in a series of layers – think of them as different sections of feathers.

DO YOUR RESEARCH

Even when you are drawing something that does not exist in reality, having a basis of real-world knowledge for your ideas will make your results much more believable. Look at photos of real animals for a better understanding of how their shapes work from different angles and positions.

LONG JOINTED "FINGERS"

CLAW

⊙ BAT

Bats may be difficult at first, but using simple shapes makes them much easier! They have small round bodies and heads, often huge ears, and very short, thin hind legs. The wings are essentially long arms that end with a sharp claw, and from there they have extremely long "fingers" that connect the wing together. You can use circles to map out the "knuckles" inside the wings.

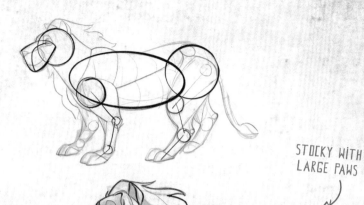

◉ LION

A lion is constructed with circles and cylinders, again with smaller circles indicating the joints. It is best to draw the lion's mane after you have figured out its body. They have large heads, stocky bodies (if well fed!), and fairly large feet. You can construct a lion with one big, long oval for the body, connected to two smaller spheres for the head and rear.

STOCKY WITH LARGE PAWS

◉ HORSE

Horses have complex anatomy that is tough to master, so be sure to reference lots of photos and try to match these basic shapes to real horses that you see. The shapes are very different to a human, but the ideas are the same, using cylinders and spheres to create limbs, muscles, and joints. It helps to have a central line going down the middle of the horse's body, from its head and neck through to its torso and hindquarters, to help you join the forms together.

CYLINDRICAL BODY WITH LARGE MUSCLES

DESIGN TECHNIQUES

BY MARTIN J. ABEL

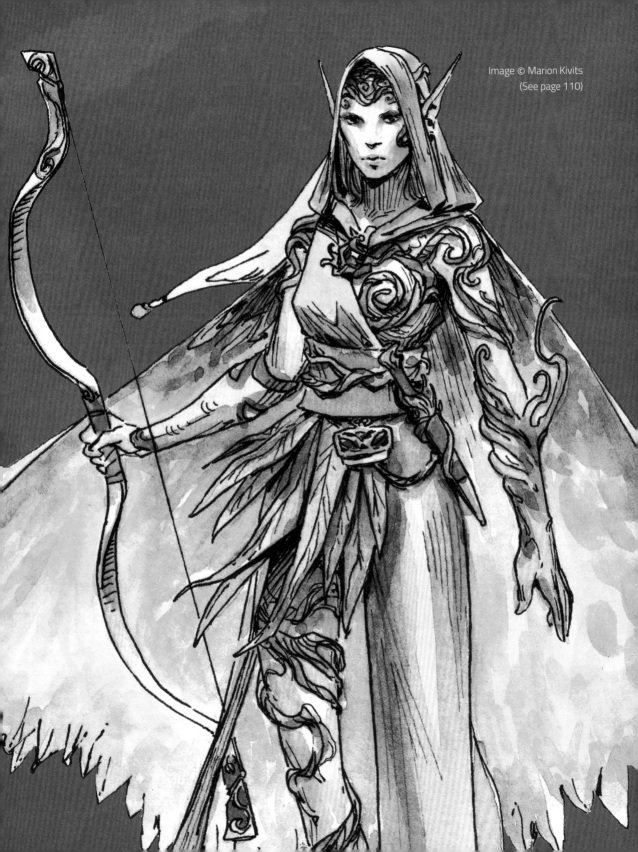

FORESHORTENING

Foreshortening creates a sense of perspective by showing forms at an angle. This can make a figure or scene exciting and dramatic, with objects coming towards or receding away from the viewer. It also adds realism, so your characters do not appear flat and stiff. Without foreshortening, your figure drawings will look flat – devoid of life and believability.

In the bottom left example, all the shapes of the human body are there, but they lack the perspective that gives us foreshortening. By applying perspective to the geometry – so distant shapes are smaller and nearby shapes are larger – we can create foreshortening in our character drawings, like in the right-hand example below.

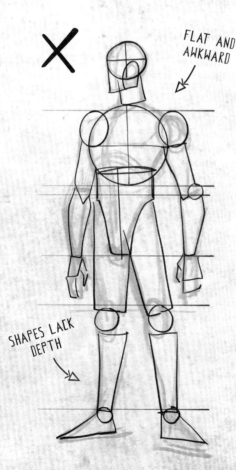

FLAT AND AWKWARD

SHAPES LACK DEPTH

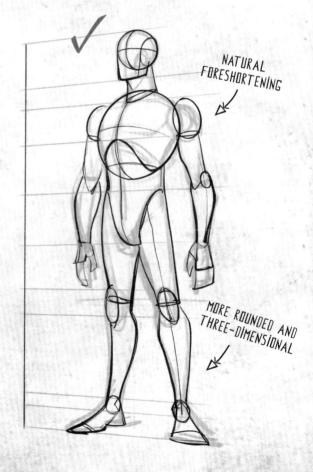

NATURAL FORESHORTENING

MORE ROUNDED AND THREE-DIMENSIONAL

ANGLED
PERSPECTIVE LINES

⊙ STANDING POSE

Here is a casual standing pose, for a simple example. Following the perspective guidelines, we can see that everything on the right, being further away from us, will be smaller than the left of the drawing which is closer to us. For this straight pose, all the anatomy of the body is following the perspective guidelines, which are shooting off into the distance.

⊙ DRAMATIC FORESHORTENING

The foreshortening in this pose is more extreme, with the perspective guidelines receding at a steeper angle. Aiming a bow is an especially tricky pose to figure out, and I highly recommend studying some photographs of people holding and shooting with a bow. In this pose, the most foreshortened aspects are both arms and the bow itself. Imagine the arms as geometrical cylinder shapes that are pointing towards the viewer.

EXTREME
ANGLE

POSES

Now that we have covered how to construct a basic figure, let's look at how to make some exciting poses that will add life and dynamism to your fantasy characters.

HEAD IS HUNCHED LOW

◉ READY FOR ACTION

A stealthy assassin, crouching ready for silent action, will usually be low to the ground, hunched forward, perhaps with one arm forward and one arm back, both holding daggers. One important tip in creating this pose is to notice that there is not much of a neck; it is there, but with foreshortening and how the body is bending forward, the head shape is half below the line of his back.

FEET WIDE APART FOR BALANCE

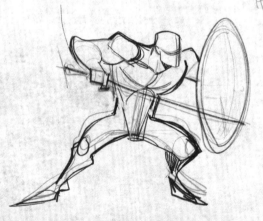

BODY AND SHIELD BRACED FOR IMPACT

◉ BRACED FOR IMPACT

Creating this determined action pose is done by emphasizing the forward neck, raised shoulders, spread legs, and a slightly forward stance. Once you flesh out the details and add armor, the knight is battle-ready! A determined facial expression, with a frown and gritted teeth, also goes a long way to express a determined attitude.

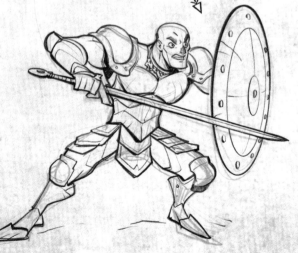

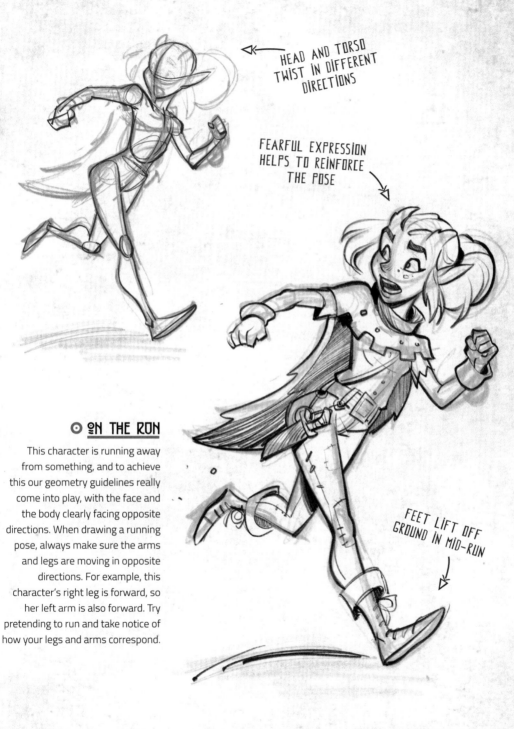

HEAD AND TORSO
TWIST IN DIFFERENT
DIRECTIONS

FEARFUL EXPRESSION
HELPS TO REINFORCE
THE POSE

FEET LIFT OFF
GROUND IN MID-RUN

⊙ ON THE RUN

This character is running away from something, and to achieve this our geometry guidelines really come into play, with the face and the body clearly facing opposite directions. When drawing a running pose, always make sure the arms and legs are moving in opposite directions. For example, this character's right leg is forward, so her left arm is also forward. Try pretending to run and take notice of how your legs and arms correspond.

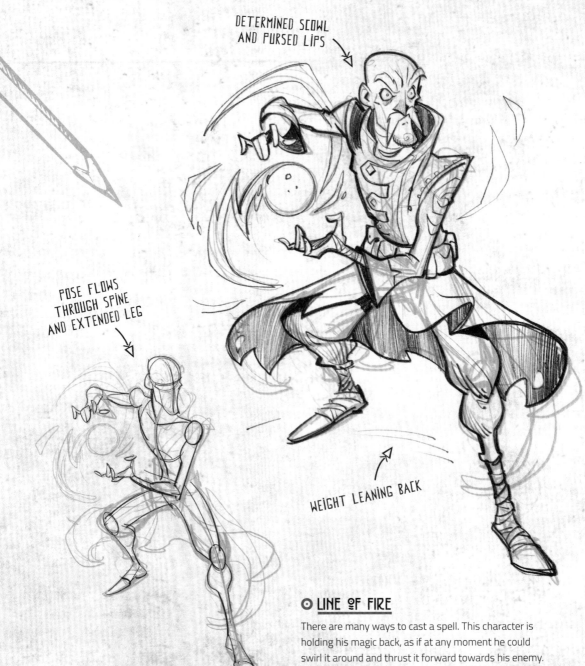

DETERMINED SCOWL
AND PURSED LIPS

POSE FLOWS
THROUGH SPINE
AND EXTENDED LEG

WEIGHT LEANING BACK

◉ LINE OF FIRE

There are many ways to cast a spell. This character is
holding his magic back, as if at any moment he could
swirl it around and thrust it forward towards his enemy.
To capture this moment before a magical attack, I make
sure that most of his body weight is on his right leg,
and that there is a clear sense of direction in the pose.

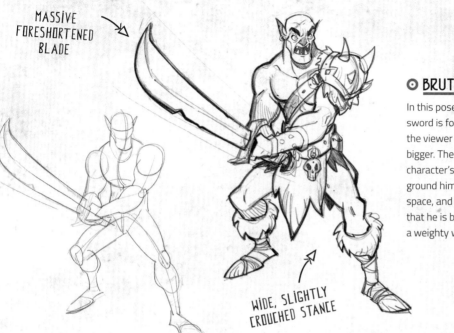

MASSIVE FORESHORTENED BLADE

⊙ BRUTE STRENGTH

In this pose, the large two-handed sword is foreshortened towards the viewer to make it appear even bigger. The wide stance of the character's feet and legs helps to ground him in a three-dimensional space, and give the impression that he is bracing himself to swing a weighty weapon.

WIDE, SLIGHTLY CROUCHED STANCE

⊙ STARTLED STEED

This classic pose of a rearing horse is something you are bound to want to draw eventually! Like with anything, studying photos of horses will help in figuring out how to draw this pose. One front leg is higher than the other, so the pose is not completely symmetrical, making it more dynamic. The mane and tail add even more action as they are flung back, and the facial expression adds the element of fright.

BODY LEANS UP AND BACK

MANE AND TAIL ADD MOTION

LIGHTING

Lighting can seem complicated, but to get started, all you need is a grasp of a few simple lighting scenarios that will give your images atmosphere and depth. Lighting plays an important part in storytelling, so have fun, and always think about the effects you can create with lighting to push your character designs and stories. How can lighting make a scene more dramatic, or create a sense of where the character is?

◉ SIMPLE FLOOR SHADOW

This lighting setup is very simple, with a shadow directly underneath the character on the ground. While this is primitive, it still indicates that the light source is above, and establishes minimal depth in the scene. It is a quick, easy solution that grounds the character.

◉ LIGHTING FROM THE FOREGROUND

The lighting scenario shown above has a flattering light source from above and in front of the character, which casts a slight shadow towards the lower right. It conveys a sense of depth without being too dramatic, and can be applied well to most types of concept.

◉ LIGHTING FROM BEHIND

By putting the light behind your character, they can almost become a silhouette, with just a sliver of light bouncing on the outlines of the figure. Perhaps this goblin has just finished a battle, and the sun could be setting behind him?

LIGHTING FROM BELOW

Lighting from below creates a very dramatic effect, often giving the character a menacing or spooky appearance. As with lighting from above, and all angles, you have to use your imagination and references to figure out where the light would land.

LIGHTING FROM THE SIDE

Moving the light off to the side really pushes the intrigue of the illustration into a new direction. Perhaps a door has opened beside our character, indicating someone's approach, and the light is showing through. Changes in light can imply many things!

LIGHTING FROM ABOVE

Moving the light source to directly above the character changes the mood much more dramatically. When coloring light, it is essential to know where your light source is, and how it lands on some surfaces but not others. In this case, areas like the character's neck are not hit by the light at all.

DESIGN VARIATIONS

Part of developing a good design that tells a story is exploring different interpretations and solutions. You may find your initial idea has mileage in ways you hadn't considered before! Here we will explore how changes to color palettes and small details can put a fresh spin on a character.

NEUTRAL PALETTE AND COSTIUME

⊙ STANDARD WIZARD

This is a fairly standard wizard that will be a basis for the variations in this section. He is earthy in tone, to suggest that he is close to nature, but the effect is not over the top.

MENACING, SPIKY MAGIC

COLD, OMINOUS PALETTE

⊙ VILLAINOUS WIZARD

In order to corrupt the wizard into the darker realm of magic, the browns are changed to purples. He now has green lightning magic that projects a cold glow around him. Adding costume details like the skull helps to push the character into an ominous new direction.

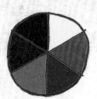

⊙ FIRE WIZARD

A simple change of hair color and adding lots of fire effects can suddenly turn the wizard into a master of the fiery element. Adding a little flame decoration to his robes is enough to complete the design without being too complex. You can spend as much time as you want adding more and more unique details.

WARM, FIERY PALETTE

MORE GREEN IN PALETTE

⊙ WOODLAND WIZARD

This version takes the "earth magic" theme much further. His wooden staff is extended to make it more wild, and his beard is now full of leaves, making him look benign and close to nature. You could go further and change all the parts of his costume to be made from leaves and twigs.

WOODLAND-THEMED DETAILS

PROCESS TIPS

BY MARTIN J. ABEL

DRAWING HABITS

Here are some simple habits that any artist can practice that will help to improve your techniques, refine your line quality, and make the process of drawing much easier.

◉ HEALTHY POSTURE

If you intend to draw for a long time, it is very important to remember to have a **good drawing posture**. Having your work flat on a table and hunching over to draw will be bad for your body in the long term, and can also cause problems with your image if you are seeing it at an awkward angle.

Instead, try propping your paper up with an adjustable **drawing board** or **easel**, or working in your sketchbook in a comfy chair with good back support so that you sit more upright. These changes will greatly save your back in the long term, and will help you to see your drawing from a good angle.

◉ DRAWING GRIP

There is not really a right or wrong way to hold a pencil, but there are two common techniques. What works best is up to you!

WRITING GRIP

OVERHAND GRIP

◉ The **writing grip** is the most common, and provides strong and steady control of the pencil.

◉ The **overhand grip** allows you to use the side of a pencil, and since your hand is not resting on anything, your movements are very free and relaxed, making your sketches rough and loose.

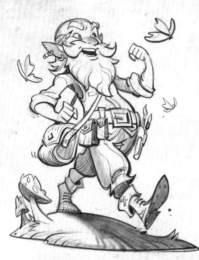

◉ TAKE BREAKS

Sometimes we just cannot draw something the way we want to, and it can be very frustrating. When you find yourself getting so annoyed that you can no longer focus, it's best to take a break. Get out into the fresh air and get your body and mind moving in other directions! When you come back, you will feel much better.

It is also important to take breaks even when you are doing a good job and feeling great, because staying in one position for too long will have a bad effect on your health over time.

◉ GOOD LIGHTING

Artists are a fickle bunch – not only do we need to have the right paper, pens, desk, and chair, but good lighting is also very important for us! Having a lamp or window on the wrong side of you is going to cause frustrating shadows over your page, which will make drawing less enjoyable.

Get a lamp, window, or light source on the opposite side to the hand you draw on, so shadows do not get in the way of your drawing. Of course, it is also important to make sure you are not straining your eyes trying to see in the dark!

◉ LINE CONFIDENCE

A lot of people when starting out drawing will sketch using lots of little lines, often called **chicken scratching** or **hairy lines**. As you grow as an artist you will become more confident at creating single flowing lines, and a lot of that has to do with practice and knowing how to control your equipment.

HAIRY LINES

LINES AFTER PRACTICE

RESEARCH

Whatever you are drawing, however realistic or fantastical it is, you will benefit from taking the time to research. There are many different ways to find reference material and expand your mental library of subjects.

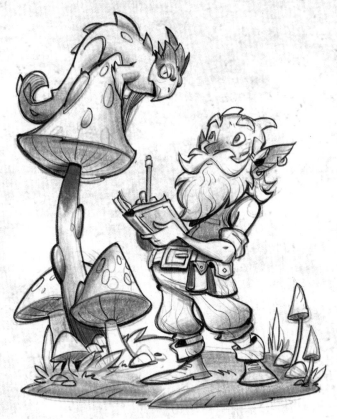

◉ DRAW FROM LIFE

Not only is getting outside into the real world important for your health, but taking your sketchbook outside and drawing plants, animals, buildings, or anything, is very valuable. You can also take life drawing classes, where you can get the chance to draw real people posing – the most valuable thing for learning how to draw human anatomy.

◉ SEARCH ONLINE

With references so easily available on the internet, we have no excuse not to do some research on the things we want to draw! Understanding your subject matter will help you to draw it more successfully. References will help you to understand why castles are built in the manner they are, or how to correctly hold a sword. We have an amazing ability to gather lots of information from online. Consider making folders on your computer for references of all the subjects you are interested in. They are guaranteed to come in useful.

⊙ FILM AND TV

Films and TV are great sources of inspiration, especially when it comes to genres like fantasy. If you are feeling a little uninspired, try to find some TV shows or films related to your drawing interests for a hit of motivation! You can also find documentaries online or at your library on all sorts of topics, including how to draw and paint.

⊙ READ BOOKS

While we have the internet at our fingertips, do not underestimate a simple trip to your local library. Finding a book devoted to the topic you need to research is sometimes way more valuable than searching online for hours on end! Having a good collection of reference books is great, but art books and books that just inspire you to draw are also valuable to have in your collection.

⊙ TAKE PHOTOS

Along with gathering references online and from books, it is fun and helpful to take photos for reference when you are out adventuring the world. It will come in useful to have your own photos of mushrooms, trees, animals, or buildings. It also makes your drawings more unique when you are referencing from photos you have taken yourself, as opposed to images online which many other artists could also be referring to.

THUMBNAILS

Thumbnails are a key technique used by experienced and professional artists, helping them to develop the best drawings possible. By sketching out as many small, quick "thumbnails" as possible, you can quickly see which ideas look the most effective and exciting, without spending a lot of time on an idea that will not work.

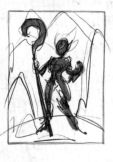

⊙ THUMBNAIL EXPLORATION

When coming up with an idea for an illustration, it helps to draw a handful of variations of the same idea. Sometimes the first thumbnail you draw will be your favorite, but you never know what might come from trying things in a new and different way. These thumbnails explore different ways of framing a scene and composing a character.

⊙ SILHOUETTE THUMBNAILS

When coming up with a character pose, silhouette thumbnails like those shown below can be great, because they focus on the overall solid shapes, without getting distracted by lines, details, and anatomy. Some artists prefer to use silhouettes for thumbnails, while others use line sketches.

CREATE SILHOUETTES WITH A MARKER OR BRUSH PEN

GESTURE SKETCHES

Another useful way to draw character thumbnails is with gesture sketching. These quick, fluid drawings aim to capture the essence of a pose, and often convey lots of motion. The focus is on the flow and energy of the lines and poses, rather than the details and anatomy.

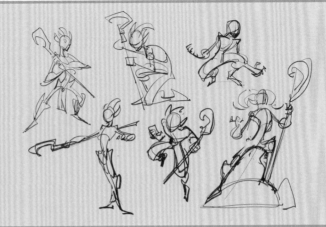

CHOOSING THE IDEAL THUMBNAIL

Here are two thumbnails from the start of this section. The first one shows a very strong, iconic composition. I want the character to feel powerful, and this angle helps to convey that. The second thumbnail is the weakest – it is an interesting angle, but looking downwards does not help to convey the character's power.

DEVELOPING THE IDEA

After choosing the strongest thumbnail, you can enlarge it and add more details to it. This version establishes that the character is made from leaves, and reinforces the flow of his magic and the rocks to help compose the image. This could now be taken forward to create a more detailed drawing.

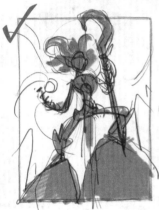

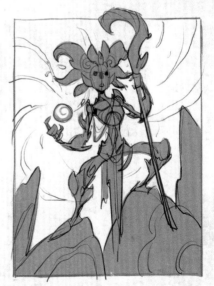

STORYTELLING

The most intriguing drawings are those that lure the viewer in with a story. This might be with a character's expression or pose, some fascinating props and accessories, or some dented armor and scars. These may seem like small details, but they are what will make your drawings engaging and memorable, as if the characters come from a real world and have their own stories. The viewer will want to know more about them! Here are some useful pointers to consider.

⊙ Creating your own story and world is called "worldbuilding." Sometimes it can come very easily and inspiration flourishes out of nowhere, but more often than not you might feel like you are scraping the bottom of the barrel for ideas. This is when taking a break, exploring the outside world, reading books, or visiting your favorite fiction can really help to jump-start your inspiration again.

⊙ I have found, through trying to develop my own story world, that just drawing and creating characters, slowly figuring out who they are and what their backstories are, can be very beneficial to establishing a world of your own.

⊙ Of course, if you want to move on to actually producing a story or a product, you will need to spend a lot of time doing more than just drawing characters. Make sure you spend time writing down all your notes on how characters fit into your story's world.

MOTIVATION

As a beginner artist, the world of drawing can simultaneously be extremely inspiring and terrifyingly frustrating! Sometimes you can draw something over and over again, and it just does not seem to work. The easiest thing in the world is to quit drawing when it gets hard. But nothing worthwhile is easy, so I encourage you to stay strong, go easy on yourself, take a break when needed, and then try again!

⊙ One of the best things to accept early on is failure. Failure is an artist's best friend. Every time we fail we have a chance to learn how and why, and to come back stronger, knowing just that little bit more on the second or third time around.

⊙ Expecting to fail, and knowing that it is okay to do so, is also crucial in your positive outlook to drawing and learning. Nothing is ever perfect, even when you get older or become a professional artist. You are always going to continue to learn new things.

⊙ Drawing is a very rewarding hobby but can also be an amazing profession. There are lots of opportunities out there to become a professional artist in many different industries, such as creating comic books, concept designs for video games, TV, and film, and art for board games and magazines. The list is almost endless.

⊙ One of the best things to do is to work on personal projects, even if you are drawing other things as a professional. Working on your own stories or ideas is always important, as you will own these and they are an investment in yourself.

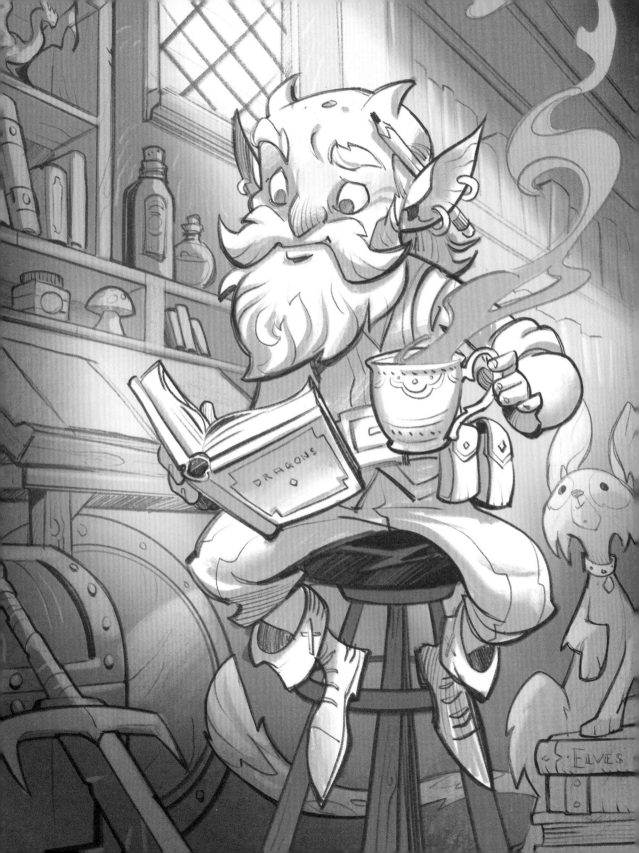

TUTORIALS

Now that you have been introduced to the basics of drawing and design, let's jump into creating some fantasy characters and creatures. There are ten tutorial projects in this section, each for a different subject, by different artists with their own unique styles. Each artist has their own approach to things such as thumbnails, construction, and coloring, so make sure you try a few different approaches to see what works best for you. Each project follows a structure, as outlined below, that is useful for any artist to practice.

◉ RESEARCH

As you saw on page 60, no matter what your idea is, you will always be able to execute it better by doing some research first. See what each artist researches, and then try looking up some references of your own.

◉ THUMBNAILS

Use your thumbnailing skills, as covered on page 62, to help you sketch and choose the best proportions and composition for your design. Aim to choose one or two of your best ideas to develop into a full drawing.

◉ FOUNDATIONS

You can't build a good drawing without a strong foundation. Observe how you can create the very simple building blocks of the figure before drawing anything detailed.

◉ BUILDING UP

This is where the full-size pencil drawing starts to take shape. Each artist includes three "Design Focus" tips if you need help with drawing difficult areas such as heads and hands.

◉ IDEA INVENTORY

Here each artist explores a few options for weapons, clothes, and accessories that could put a different spin on their final design or be useful for a future interpretation. You might find a totally different twist that you would like to try!

◉ FINAL SKETCH

The pencil sketch should now be tidied up and ready for inking. If you like, you could call your piece finished now – but ink and color will take your design to the next level.

◉ INKING

In this stage you will finalize your drawing with ink, carefully creating a clean, refined version that you will be able to color. Follow how each artist finesses their drawing with hatching, textures, and line thicknesses.

◉ COLORING

Now you can finish your image with some simple colors. You should be able to follow along with whatever coloring tools you have available – pencils, markers, or even watercolors. Just check the colored flags on the top of the page to see what colors you need.

DOWNLOADABLE RESOURCES

Drawing can be very challenging yet rewarding, and we encourage you to analyze each artist's drawings and develop your own approach with their advice. Getting stuck sometimes is inevitable though, and that's where the book's downloadable guides will come in useful.

Visit **store.3dtotal.com/resources** to find templates and guidelines for each project. Maybe you would like to practice making multiple base sketches, try out different costumes on a character, or just practice your coloring techniques on some blank line art. Download the files and print them on white paper to help you out.

Image © Martin J. Abel

CHARACTERS

KNIGHT

BY JOHAN EGERKRANS

In this tutorial we will be creating a sword-wielding knight in armor. He will not be a kindly, gallant hero though – instead he will be a proud, stern nobleman with more than a hint of arrogance to him. He may be on the side of Order, but not necessarily on the side of Good. A heavily stylized approach, using strong inking and harsh angles, will help to bring out this character's personality, while research into historical armor will keep the design grounded in reality and give it an authentic flavor.

TOOLKIT

- ⊙ Graphite pencil
- ⊙ Eraser
- ⊙ Colored pencil
- ⊙ 1.0 mm and 2.0 mm calligraphy pens
- ⊙ Colored marker pens (see page 79 for color palette)
- ⊙ Ruler (optional)

RESEARCH

An understanding of how real medieval armor is designed will help to lend authenticity to this fantasy knight. Before we put pen to paper, let's look at images of late-medieval plate armor from the fourteenth and fifteenth centuries to get a feel for how the various parts go together. You can search for this both in books and online. The knight will be armed with a huge blade, so let's research swords as well.

SHIELD › This character may carry a shield for protection, or wear a small jousting shield near his shoulder as a more ceremonial-looking option. Either would present a good opportunity to add some color to his gear.

ARMOR › The knight's torso will be protected by a metal breastplate. On top of that goes the "gorget," a separate piece that protects the neck. These essential pieces of body armor will immediately convey the character's role.

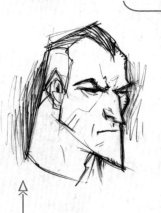

SWORD › The knight will undoubtedly be armed with a sword – that most time-honored weapon of any self-respecting hero! It would be a simple weapon to suit a serious, practical fighter, but could be styled to match his shield and armor.

FACE › The knight will have stern, noble features. Drawing with angular strokes will help to put this across. Bristling eyebrows, a severe hairline, and a few wrinkles and frown lines will also convey that this is not a young hero but a hardened fighter.

HELMET › To protect the knight's head, he could wear a type of helmet called a "barbute" – a close-fitting helmet with a Y-shaped slit to see out of. However, he may not be wearing it in the final image so that we can clearly see his face.

THUMBNAILS

When thumbnailing, explore powerful shapes and easy-to-read poses, as you want the knight to make a striking impression. He should be an imposing and authoritative figure, with a silhouette that combines nobility with a streak of brutality. A squat, blocky shape veers to the brutish side, while a slimmer one may look too frail. Try to find a balance – while not necessarily a heroic character, he should have the stature of a classical hero.

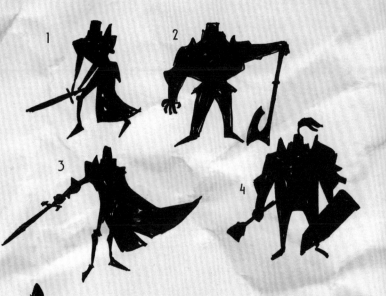

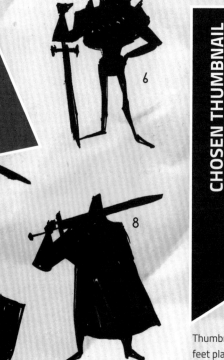

CHOSEN THUMBNAIL

Thumbnail 5 works best. The grounded stance, with feet planted firmly apart, lends an air of confidence. The sword provides an interesting diagonal element that makes the pose more dynamic. All it needs is a long cape to give the final composition an eye-catching flow, which can be borrowed from one of the other thumbnails.

 # FOUNDATIONS

Let's set the groundwork for the drawing, beginning with a skeleton consisting of basic shapes. Taking inspiration from the chosen thumbnail, sketch a stick figure using a colored pencil, following the pose of the thumbnail. When that is satisfactory, the arms, legs, and torso can be blocked out as tapering tubes.

BASE

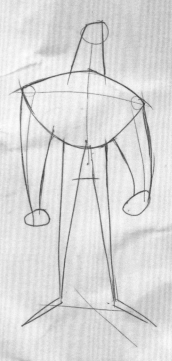

⊙ Draw an almost eye-like diamond shape for the knight's torso. The upper arc will give him broad, muscular shoulders, while the lower arc gives shape to the rib cage.

⊙ To give the character "superhero" proportions, make his head relatively small. This will make the rest of his frame appear taller and more imposing, enhancing the broadness of his shoulders.

⊙ A cross or simple grid in perspective gives you the plane of the surface he is standing on, which makes it easier to place the knight's feet firmly on the ground. Thin legs and sharp feet create contrast with the shapes of his torso and arms.

LINES

⊙ Start defining the head using bold, angular shapes. The chin is more or less a triangle at this point. This feature instantly conveys the knight's personality: he's stern, sharp, and even somewhat menacing.

⊙ Sketch the knight's elbow armor as simple triangles at this stage. Position these triangles over the knight's elbow joints; you can define them more clearly later. Sketch the outline of the helmet in his hand, adding a cross to denote the vision slit.

⊙ The knight will be wearing plate armor called "pauldrons" on both shoulders. One pauldron has a high crest on it that protects the knight's head from attacks, as well as adding a dramatic, asymmetrical swoop to catch the viewer's eye.

BUILDING UP

With the basic shapes in place you can start defining the separate armor elements, facial features, and other medium-sized details. The important part of this stage is to get the knight's face right as it sets the tone for the entire character. Continue sketching using a graphite pencil, but apply a little more pressure at this stage.

◉ Add the fastenings for the knight's cape at his shoulders, though bear in mind that one is slightly concealed by the larger pauldron. Don't add the rest of the cape yet.

◉ Define the neck and shoulder armor by sketching out their full outlines. When placing the edges of these plates, remember that medieval armor is segmented to make movement easier, and fits surprisingly close to the body. It's almost organic.

◉ Make the corners of both pauldrons pointed for an interesting balance between their smooth, rounded inner edges and their sharp outer angles. The pauldrons match apart from the high crest on one side.

◉ Add a tunic underneath the knight's armor, and a belt. These can be blocked in as simple rectangles, but try to give them flow and weight with some slight curves, so that they hang off the hips in a natural fashion.

◉ Define the middle of the breastplate with a curved vertical line. As you add the separate segments of the armor covering the knight's belly, their shapes should taper off to a point at this central line.

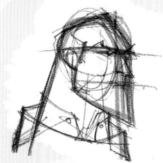

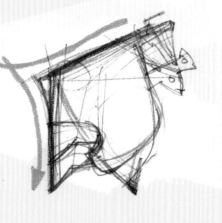

HEAD > In less stylized human anatomy, the eye-line generally falls halfway down the skull, and the mouth falls halfway between that and the chin. However, to create this knight's exaggerated proportions and bold personality, divide the head evenly into thirds. This way, the eye-line is high up on the head, which will make him more distant and aloof, and his stern jaw dominates a third of his face.

PAULDRONS > When drawing the contours of the pauldrons, use curved strokes to give them smooth outlines and dangerous, thorny points. Make sure the point of the pauldron sits out from the geometry of the arm, distinguishing its shape from the underlying anatomy while still maintaining a close fit.

HAND > Drawing hands is always one of the hardest and most important parts of a character. When holding an object such as a handle, the closed fist can be simplified into a diamond-like shape similar to the one we used for the torso. Note how the index finger sticks out slightly from the rest of fist, to give the hand a more natural shape.

DESIGN FOCUS

IDEA INVENTORY

SHIELD > Small jousting shields were sometimes part of a knight's armor, serving to protect the knight's left-hand side when jousting. They offer the perfect opportunity to play around with some heraldic designs. There are plenty of books on this subject if you are looking for inspiration. Keep the designs flattened and highly stylized. Cutting curves out of the basic shield shape is a way to make some interesting asymmetrical variations.

The cross is a good choice of decoration, as elements of it can be worked into the armor design as well.

SWORD > No weapon is more knightly than a sword. As a weapon with a lot of personality, the sword's design should reflect the wielder's character – in this case, steely, rigid, and authoritative, with hard, straight lines. A rounded, leaf-shaped blade would feel more benign, while a jagged blade would read as straight-up evil!

The right-hand design allows for some heraldic elements to be incorporated into the hilt and crossguard, echoing the design of the jousting shield.

FINAL SKETCH ▶

Now you can begin to reinforce the design's details, using firmer pressure on the pencil, and clean up guidelines that are no longer necessary. You can also add one final element to the costume: the long, flowing cloak that was touched on in the thumbnailing stage. It is a deceptively simple part of the design that adds a lot dynamism and gravitas to the character, as well as providing a backdrop against which the knight's armor will really stand out.

⊙ An angular hairline can make a character look severe or even villainous. Giving the knight a sharp, slightly receding hairline and widow's peak enhances his strict, seasoned demeanor. Use straight lines and very few curves to capture this look.

⊙ The shield from the Idea Inventory forms the basis of many recurring elements in the design, such as the star-shaped triangular details and sharp, fang-like points. Motifs like this can help to tie a whole design together.

⊙ Use a light grip and alternating, swooping curves to indicate how the fabric of the cloak flows in the breeze, giving form to the material. If you get heavy-handed with these lines, they will look too straight and severe – it's one area where we want to avoid this quality!

⊙ Echo the segmented details of the torso armor elsewhere in the design. If the pauldrons, gauntlets (armored gloves), and foot armor share the same detailing, such as ridges and round studs, it makes the full suit of armor feel like a cohesive whole.

⊙ Give the tunic a pointed pattern at the hem by alternating triangular and square shapes in the fabric. This adds interest to the garment, as well as tying it in firmly with the visual language of the knight's armor and anatomy.

INKING

Use 1.0 mm and 2.0 mm calligraphic pens to ink the sketch you've created. I want the lines to have an antique tint to enhance the final colors, so I choose sepia-toned pens, but black works just as well. If you do not have calligraphic pens, you can create a similar quality by revising the lines you have drawn and adding some tapering and extra variety. For example, you can add dark corners in the armor with a thicker line, and use thinner strokes to capture the flowing cloak and fine lines on the knight's face.

◉ Filling solid areas with ink creates eye-catching contrast, which is what you need to draw the viewer's attention to the knight's head and face. Achieve this by filling in his hair and the interior of the larger pauldron with solid color.

◉ Add lines of scribbled shadow to suggest bends in the armor, or areas where the darker side of a shape meets a reflected light from the other side of the scene. This technique is more subtle than the outer lines, and is ideal if you find any forms are looking shapeless or unclear.

◉ You can use a ruler to draw the straight edges of the sword. However, do not forget to vary the pen pressure or go over the lines freehand afterwards to create variation, or the results will look too plain, lacking the same personal touch as the rest of your image.

◉ Draw overlapping "U" shapes to create the scale mail in between the knight's armor plates. Don't overdo this detailing though – just suggesting the shadowed areas of the scale pattern is enough. Work from thick lines, to thin lines, to pure white space to achieve the effect of a curved surface.

COLORING

A color palette of gold, orange, and red hues will give the knight a wealthy, noble appearance. Use a light-colored marker to build up the midtone areas, and a more saturated color for darker areas; in this case, to create a bronze sheen, use a light and a dark yellow-orange. The sword blade and secondary armor elements are gray for variety. Use bold red for the cloak and shield, a peach skin tone for the face, and browns for the clothes to keep them more neutral. To add shading to these secondary areas, you can use a complementary purple hue over them.

◉ Apply the peach skin tone to the knight's face in moderation, letting his angular features catch a lot of the light. Build up the color around his square jawline and under his scowling brows to enhance his severe look.

◉ Leave a highlight in prominent areas where the light hits, such as the curved center of the breastplate – this highlight is almost the pure white of the paper. Areas that are less focal, such as his arms and legs, do not need highlights as bright as this.

◉ The knight's tunic and cloak are colored more evenly than the armor, creating a matte appearance that is appropriate for these soft materials. When the flat color is dry, add shadows with the same marker or the purple marker to introduce some extra form.

◉ Use dabs of the darker orange marker to indicate dents in the knight's armor. Do not apply so many that they become distracting – just enough that the armor looks like it has seen some combat!

ROGUE

BY ROMA GEWSKA

In this tutorial we will be creating a dagger-wielding goblin rogue. The character's pose, outfit, and accessories will show a determined and daring personality – tough and practical, but a little quirky. A dark, muted color palette will help to convey her profession as a cunning thief or mercenary who operates in the shadows, and exaggerated proportions will help to convey her slightly smaller-than-human stature.

TOOLKIT

- Graphite pencil
- Eraser
- 0.3 mm and 0.7 mm black fineliner pens
- Colored marker pens (see page 89 for color palette)
- Ruler (optional)

RESEARCH

When we think of a fantasy setting we usually think of elves, dwarves, and dragons, but there's a key element to all of these: a time frame. A lot of fantasy stories take place in a time similar to our world's medieval period, so researching clothing and objects from that setting will help you a great deal when creating any type of fantasy character. You can find a lot of information on the internet or in books.

CLOAK › Most rogues are criminals who might lose easily in a fight, so when a situation is looking bad, the best they can do is to flee and hide. A cloak would help our rogue to do this.

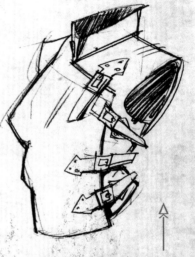

FACE › This rogue should look fun and cunning. A cheeky smile and confident look in her eyes will help to establish her character.

ARMOR › Rogues are fast and lethal, so when thinking of their armor, you need to go for something light. Cloth or leather would be ideal, avoiding metal parts that would slow the rogue down.

DAGGERS › A rogue would definitely use a small, discreet weapon that is easy to hide under clothing and would not slow their movements down. Daggers would be perfect for this.

BELT BAG › Any self-respecting rogue needs to have a bag where they can store important items, such as lockpicks or potions. A bag on the rogue's belt would be a good choice, as it would not interfere with movement.

THUMBNAILS

The first thing that might pop into your head when you think of a rogue is a dark, shady individual that in the best-case scenario will leave you with no coins in your pockets. Rogues can be different — adventurous, mysterious, and mischievous — but all of them are most definitely dangerous. When thumbnailing, use triangular silhouettes and poses that show off the rogue's weapons, as the sharp forms will give the viewer a sense of danger.

1

2

3

4

5

6

CHOSEN THUMBNAIL

7

8

Thumbnail 1 is sharp and edgy. Even though the character is just walking toward the viewer, the triangular shape gives off a dangerous, focused vibe.

FOUNDATIONS

Before you start drawing all the details of the design, you need a good foundation on which to apply them – the basic body shape of a character. For this stage, use a graphite pencil and try to apply the strokes as lightly as possible, so that when you need to erase them, you do not damage the paper. Let's start assembling the figure from basic shapes.

BASE

◉ The character is a small goblin girl, so make her head proportionally large, using similar proportions to those of a child. This helps to show that she is smaller than a regular adult human.

◉ When drawing a character standing with most of their weight on one foot, give their shoulders and arms a different angle from the hips and legs. This is known in art as *contrapposto*, and gives the figure a more dynamic and natural appearance.

◉ Women's legs are often wide at the hips and narrow at the ankles. Use triangular shapes that decrease in width from top to bottom to show these dynamics.

LINES

◉ Sketch the face using a basic dividing line down the center. We want to give her a look of mischief, so having her face angled slightly downwards while still staring at the viewer will achieve this.

◉ The character's figure can be defined as a bean-like shape. Add curves to define the character's chest and hip bones. The rest of the shape can stay the same for now.

◉ Divide the legs in halves to show where the knees should be placed, then add curves to indicate the thighs and calves. Twist the alignment of the knees to match the angle of her hips, so that the knee further from the viewer falls a bit lower down than the other.

BUILDING UP

This stage is where you can start applying the large and medium-sized elements of the character's outfit. Start with something big that was established in the thumbnailing stage, such as the cloak, and slowly work up to the medium-sized elements, such as her body armor and main items of clothing. Don't touch the small details like the buckles or clasps, as at this point they would just be a distraction.

◉ Give the rogue a vest that has a fastener on its side. Working together with the way her cape is set up, these two garments create a great guideline that directs the viewer to her face.

◉ This rogue should look like a professional who has been through a lot, but also has the vibe of being less wealthy than she would want to admit. Tearing her cloak and shirt a little will do the trick.

◉ Giving a character some asymmetrical design elements can show their scruffy side, which works well for the rogue. In this case, give her leather leg armor, but just for her right leg.

◉ Make her belt bag slightly larger to give the impression of it being a little big for her. This emphasizes her small stature. You may also wish to start looking for different references for how those buckles will work.

◉ Draw an oversized boot on her left foot to create a sense of stability, visually balancing out the leather armor on her other leg. The oversized boot also gives the impression that she's small compared to a human.

DESIGN FOCUS

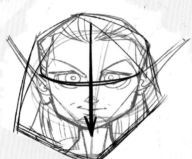

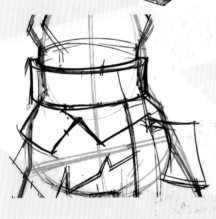

FACE › Start working on the face by drawing vertical and horizontal lines that divide the face into quarters. The vertical line will help you to draw the features evenly, and the horizontal line is where you should place the eyes. The eyes are the starting point for all the other facial features, such as the nose, brows, mouth, and ears.

CLOTHING › Every item of clothing has its own volume. Make the rogue's garments wider than the underlying body shape, so that her clothes don't look paper-thin. Different materials will have different volumes, and need more or less space. Some elements may overlap; for example, belts usually overlap themselves when you fasten them. Keeping this in mind will give your drawing more authenticity.

HAND › Drawing hands can be tricky for a lot of people (see page 38). Try to find references that will be useful in your drawing, or just take a photo of your own hand at the desired angle. Start by drawing a basic rectangular shape that will represent the palm; sketch another that represents the fingers, and divide it into four to indicate each finger; and finally add the thumb.

IDEA INVENTORY

DAGGERS › Rogues' weapons can be as different as rogues themselves. The first dagger is quite simple – it might belong to a dirty thief from the slums, which is ideal for my character. The second one is better suited to a character from some kind of forest tribe. The third one is a magical dagger that might belong to a dark cultist.

The unadorned triangular shape of the first dagger fits best with the rogue's backstory and visual language.

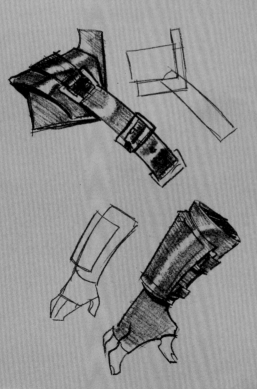

ARMOR › Different types and pieces of armor will give your character very different looks. If you want them to look wealthy, give them a full set of fancy, patterned armor embedded with gold. Giving your character an incomplete set of simple armor, however, will give them the look of someone who cannot afford much.

The rogue's main piece of armor will be a leather vest, which is minimal, subtle, and protects her vital organs.

FINAL SKETCH

Use your eraser to go through the drawing removing the basic guidelines, as you do not need them at this point. After tidying up the sketch, lighten it a little by going over it with an eraser, pushing the eraser lightly onto the paper. Then take a freshly sharpened graphite pencil or mechanical pencil, and start tightening up the final version of the sketch and applying small details.

⊙ Cover one of her shoulders with the cloak, as this guides the viewer to her face, as well as adding more scruffy asymmetry to the overall design.

⊙ The vest is the leather vest from the Idea Inventory. Do not add any types of pattern because that would make the vest look fancier than it needs to be.

⊙ These daggers are from the Idea Inventory. You can use a ruler to build them up, drawing the straight central line before adding the outer edges and curved forms.

⊙ Add buckles and metal elements to give logic to all of the bag's mechanics and functions. To do this, start with the basic rectangular shapes and work them into the design before adding any other details.

⊙ Add some bandages on the rogue's left leg and wrists, suggesting that she has make do with cheap ways to make her life more comfortable, rather than buying expensive armor. Use uneven strokes to make it look like the cloth is roughly bound.

INKING

Before you start to ink, lighten the final sketch with the eraser. This way the sketch will not distract you when inking, making the process easier. For the inking stage, you can use 0.3 mm and 0.7 mm fineliner pens. They are cheap and dry quite fast on paper, which avoids the potential for mess that a dip pen and ink can cause.

⊙ Indicate the rogue's hair texture by applying straight lines. This adds an additional tone for that area, showing that her hair is dark in color. If your character's hair is in the light, or light-colored, do not shade this area so heavily.

⊙ Add small glimpses of black shadow in between different elements of the outfit, such as under the cuffs of her boots and gloves, and between the straps of her bag. These give the drawing additional volume, and make the inks look more interesting and appealing. Do not overdo it or else it will look messy.

⊙ Use the thinner pen to add small, light strokes to the rogue's armor to create a worn texture, but do not add too many or they might become distracting to the viewer.

⊙ Metal is a high-contrast material, so a few black areas will help to create a shiny texture. Be sure to apply these on the sides of the blade where the shadow should be, and do not shy away from using references.

COLORING

Rogues usually keep to the shadows, so giving this character's outfit a dark, muted color palette would be the best option. It would also focus the viewer's attention on the lighter areas, such as her face and daggers. Use a simple complementary color scheme of dark, desaturated (grayish) blue for the cloak, bag, and boots, and brown for the rest of the clothing. Make her shirt lighter than the rest of her clothing, to support the lighter tone of her skin.

⊙ Cloth is the most low-contrast material used in this design. It does not reflect much light or cast strong shadows, so giving her shirt one layer of color should be enough.

⊙ As mentioned before, metal is a high-contrast material. Keeping that in mind, leave some areas of the dagger uncolored, creating a wide spectrum of tones and a lot of shiny contrast.

⊙ When shading leather, first fill the entire element with color, and then let it dry out a little. Then add another layer of the same color where the shadows should be, leaving a light streak intact to create a highlight.

⊙ This rogue is a goblin, so you can make her skin a classic green color. Try to add a light orange hue on her nose, eyes, ears, lips, and hands to create a varied skin tone that is more realistic.

MAGE

BY VALENTINA REMENAR

In this tutorial we will be creating a mage who practices dark magic and carries a snake-shaped staff. The whole design will draw on reptiles for inspiration to convey the character's cool, sinister personality. A patterned hood and chest tattoo will draw attention up towards her face, creating a striking impression through the use of bold inking and contrasting colors. The combined effect of her pose and costume will create the impression of an elegant, calculating, and somewhat evil character.

TOOLKIT

- Graphite pencil
- Black fineliner
- Black brush pen
- Colored markers and pencils (see page 99 for color palette)
- Ruler (optional)

RESEARCH

The strongest elements of this design will be the character's clothes and weapons. Mages, sorcerers, and sorceresses are often depicted with a big cloak and magical weapons, so let's explore some different options for these accessories. Other details like the character's facial expression and clothing can also help to communicate their personality and what type of magic they possess. Keep your study sketches simple at this stage, using graphite or colored pencils, though you can enhance them with markers to explore ideas for values as well.

EXPRESSION > The mage's facial expression will tell the viewer a lot about her personality. A serious expression with staring eyes works well for a character that wields powerful dark magic.

MAGIC > Magical energy can come in many shapes and sizes. A bold design like a fiery orb could definitely grab the viewer's attention, though this would also depend on the pose you choose.

CAPE > A long cloak is a classic visual hallmark of mage. Adding a unique cloak design would make our character's role immediately recognizable, and a hood would add an air of mystery that suits a mage.

STAFF > A staff is a major element that will make this character recognizable as a mage. Using organic or symmetrical shapes, and different materials such as wood or metal, can suggest different powers and backstories for the character.

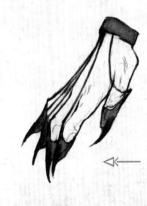

HANDS > The mage might have some physical features that emphasize her dark magic and personality. For example, clawed hands or pointed fingertips would give her a sinister but elegant appearance.

THUMBNAILS

Keep the thumbnails focused on shape and silhouette. Most mages would not use heavy weapons or have big muscles, so let's go with a slender physique for this character. A cloak would add volume to the final silhouette, balancing out her slim figure with an almost cobra-like hood. She could be holding her staff upright, in a confident pose that looks strong and brave. However, the pose where the head of the staff is pointing downwards has a more dynamic angle. This pose makes her look mysterious, like she is carefully calculating her next move.

CHOSEN THUMBNAIL

Thumbnail 7 will be perfect for the dark mage. Keeping the hood on her head will make her look secretive, and we could add an eye-catching design inside it to bring focus to her face.

FOUNDATIONS

To build the correct proportions for our mage's body, let's begin by keeping the shapes simple and geometric, ignoring details like accessories and weapons. Having a correct base figure is an important step that will help us to add clothes and accessories on top easily. Use a graphite or light-colored pencil to draw these basic shapes, and when everything is in place, use a graphite pencil to add curves and create volume.

BASE

◉ Trapezoid shapes are perfect for the rib cage and pelvis. Tilt the pelvis slightly up on one side, to shift the character's weight onto one leg and give her a more natural pose.

◉ Use circles for the elbow and knee joints, to help us when connecting the shapes together. Think of the figure as a ball-jointed doll when imagining how it articulates.

◉ Use rectangles to represent the limbs, overlapping them where her body parts appear in front of or behind each other. Compare the lengths of the rectangles to make sure the limbs are not uneven.

LINES

◉ Sketch the outlines of the character, adding ellipses inside the basic shapes to make them three-dimensional and easier to visualize. Moving one arm and one leg slightly away from the central line of the body creates a more dynamic and natural attitude to the overall rather straight pose.

◉ Use rectangles and cylinders to block out the hands and feet. You can use your own hands and feet as reference if you have trouble with this.

◉ Lightly add lines down the centers of the upper body and legs. This helps to determine the tilt of the legs and where to place features like the knees, which should fall on the center of these lines.

BUILDING UP

Now that you have made a proper base, you can start adding the fun elements, such as the the clothes and weapon as planned in the thumbnailing phase. Picking a specific theme helps to make a coherent design with a character's whole costume, so let's pursue the cobra idea that was touched on during the thumbnailing stage, adding a snake-shaped staff and almost ancient Egyptian-inspired designs to the inside of the hood. Continue using a graphite pencil for this stage, keeping your lines simple and avoiding shading.

⊙ Add a big hood, somewhat resembling a cobra's hood, to her cape to draw attention to her face. Do this by sketching out a rounded diamond shape that hangs down from the mage's head.

⊙ A cobra's hood has eye-like markings that we can translate into our design. You can do this by adding an eye tattoo on her chest which will catch the viewer's attention and give the character a dark, mystical feeling. Surrounded by the hood, it will give her an even more cobra-like appearance.

⊙ To give the character a long, lean outline, add a flowing, sleeveless robe. Imagine the robe as long, thin rectangles of cloth, pulled in slightly at the waist by a wide belt that can be sketched in with a rectangle.

⊙ The mage's staff is the final important part of the design. You have already incorporated some subtle cobra features into her outfit, so it would be perfect if the staff itself is shaped like a snake. For now, use a ruler to sketch out a straight line for the base.

⊙ Tight leather trousers will add some shine to the costume and be reminiscent of a snake's scales. At this stage, you only need to indicate the length of the trousers with lines around her ankles.

DESIGN FOCUS

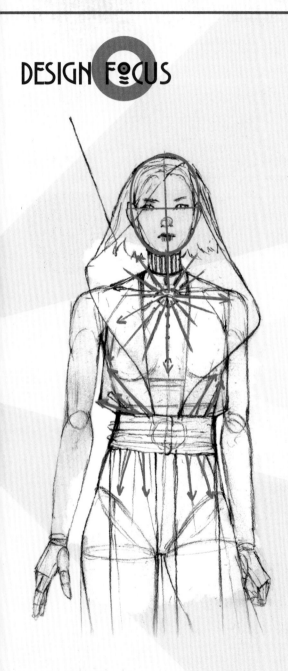

FACE › Sketch the face by drawing a vertical line down the center of the head and adding a horizontal line approximately across the middle of the face. Position the eyes on that line, then draw a circle for the nose halfway down the center line below it. Add a slight shading mark for her lips, and as she's a dark mage, give her black sclera (the "whites" of the eyes).

TATTOO › To create an eye-catching tattoo, use circular shapes with lines pointing towards the center. These will attract the viewer's eye, the same way the target of a bullseye does. Draw symmetrical lines radiating out from the central eye to create this effect.

BELT › The mage has a belt around her waist that will add wrinkles to the soft material of her robe. Achieve this by drawing lines outwards from where the pressure of the belt is applied. You can always look at your own clothes or at reference photos to create a more realistic effect.

IDEA INVENTORY

MAGIC ITEMS > Different magic items will give the viewer very different impressions of the mage. A big spellbook could be a strong focal point due to its size, especially combined with some swirls of magical energy during the coloring stage. Some potions could also add exciting color variations to the final image, though we would not want the final effect to look too colorful and cheerful.

A snake-shaped staff will add another level of reptilian imagery to the design. ⟶⟩

ACCESSORIES > The mage's accessories can make her look feminine as well as dangerous. Leather gloves would make her look somewhat tough and warrior-like, but perhaps would not fit with the rest of her elegant outfit. Light footwear, such as sandals, would make her outfit look relaxed and luxurious, as if she's a member of the nobility.

⟨⟵ **A small jewelry item, such as this snake-shaped anklet, will make her look elegant and sinister.**

FINAL SKETCH

Now you can start erasing the guides and strengthening your lines with a sharp graphite pencil. You should aim to achieve clean line art at this stage, so that you won't have any problems or uncertainties during the inking stage. Fill in solid areas such as her tattoos, but avoid shading any of the larger areas of the drawing yet. Instead, lightly draw an outline around areas where you want to have a highlight later, such as the shiny highlights of her trousers, and complete those areas with ink during the next stage.

⊙ Add straight lines on the inside of her cape, pointing up towards her face like an arrow, the same way as her tattoo does. This will establish her face as the focal point even more clearly.

⊙ The fang-like claws we explored in our research tie in well with a snake's fangs – one of its most noticeable features. As this character is a dark mage, making her nails black would be a novel, sinister touch, so shade her fingertips with pencil for now.

⊙ Short hair is a good idea when the character has a tattoo on her chest. This prevents the tattoo design from being obscured and pushed into the background. Sketch in the ends of her hair with lighter strokes.

⊙ The belt is an important accessory for completing the character's appearance and adding dynamism to her simply designed outfit. Elaborate on the belt with some extra straps to make it more visible and tie it in with the striped effect of her hood.

⊙ The anklet from the Idea Inventory adds a subtle finishing touch to the whole outfit, connecting to the cobra motif while being small enough not to distract from the main focal point.

INKING

Now that you have cleaned up all the lines, you can begin to add ink. If you are going to use markers for the coloring step, be sure to test them with your ink pens on a separate sheet of paper first, so that your original drawing won't end up smudged and ruined if the pens are not compatible. Use black fineliners and a black brush pen to achieve a variety of line widths.

◉ Ink the face carefully with a fineliner. Don't press down too hard, or the strokes will become too thick. Mark only the middle of the mouth, and the underside of her bottom lip, so that the outlines of her mouth are not too harsh.

◉ Filling the inside of her cape with black will add contrast with the mage's hair and skin, bringing attention to her face. Use the brush pen or a thicker fineliner to evenly fill these solid black areas.

◉ A fineliner is great for drawing tiny details such as the belt, buckles, and tattoo. Add thicker black areas to indicate cast shadows, such as underneath the belt straps or inside deep folds of cloth, but do not overdo this as you will be adding additional shading with colors.

◉ To create the leather trousers, we need to leave white areas for the highlights. Use the brush pen to fill the black areas, leaving thin lines of white to indicate the shine. Add wrinkles to areas like the knees by hatching a few lines over highlights, but don't overdo these or the material will no longer look smooth.

COLORING

A palette with contrast between cold and warm hues will make the mage visually interesting. Use a cool emerald green for the robe's fabric to make her clothing look mysterious and sinister. To keep the main focus on her face, use a warm color palette for her skin, belt, and the inside of the hood, and contrast it with the green robes. Use markers and colored pencils to fill big chunks of the image and add soft shading.

⊙ If you choose a soft yellow tone as a base for the mage's skin, you can add more variation to her cheeks and nose with a light pink marker, or shade her skin slightly with red and light brown pencils.

⊙ To make her trousers look really smooth, you need to softly shade the highlights. Build up gradients of light gray marker to achieve this, being careful not to make them too dark.

⊙ The staff is made out of wood, so it is not a highly reflective material, but you can add a depth and texture to it by adding darker curves along it.

⊙ The fabric of her cape is fairly thick and not reflective, so color it evenly with marker and add shading with colored pencils or a darker marker. Layering two different colors can create a new tone or a darker shade of the same color. Test color interactions on a spare piece of paper first!

BARD

BY LEON ROPETER

In this tutorial we will be creating a plucky bard character – a musician and storyteller who travels the land, impressing everyone he meets with his flamboyant costume and tales of grand adventures. In fantasy worlds, bards are often charismatic and clever figures whose songs and stories boost the morale of their fellow adventurers. This character will capture that spirit through a dashing pose, bold costume, and cheerful facial expression.

TOOLKIT

- Graphite pencil
- Red and blue colored pencils
- Eraser
- Thin black fineliner
- Colored marker pens or pencils (see page 109 for reference)

RESEARCH

Bards used to be the storytellers and musicians of medieval times, so their equipment consists mostly of decorative elements and instruments. In contrast with a knight, for example, this character does not need any heavy weaponry or armor. Instead, it's important to show that he is a traveler who wants people to listen to his songs and stories. Start with some rough sketches to get a grasp of who you are drawing.

CLOTHING > Overlapping garments and decorative patterns create an appealing contrast with the bigger shapes used in the design. This would enhance the design's readability and create an interesting character.

INSTRUMENT > Next to his voice, the bard uses musical instruments to tell his stories. This is probably the element that defines his design the most, so study a few options.

POSE > A good pose for the character would be him singing or telling a story. This not only looks engaging but also allows us to do some storytelling ourselves!

CAPE > A long cape would give the character an interesting silhouette. Study different kinds of capes to see how they might influence the overall feel of the bard's appearance.

HAT > A hat is one way to make the bard look fancy. Adding some feathers would further amplify this decorative effect.

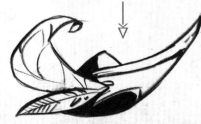

THUMBNAILS

Try to draw thumbnails roughly, but with just enough detail that anyone could understand them quickly. Two things are most important at this stage: the story you are trying to tell with the pose, and which shapes you can use to create a visually appealing image. Do not worry too much about anatomical correctness here. Quick and expressive sketches help you a lot with figuring out what you want to show.

1

2

3

4

5

6

7

8

CHOSEN THUMBNAIL

Thumbnail 5 not only has an easily understandable silhouette, but also incorporates a bit of the environment into the design. This element of interaction will help to define the character by suggesting his surroundings.

FOUNDATIONS

You can use a lot of triangles to shift the character's weight to the upper body, leading the viewer to what is important in the design: the head, arms, and instrument. Use a red pencil to sketch a quick base, and then jump right into drawing the basic anatomy with a graphite pencil. Solid base anatomy creates the simple foundation needed to layer all the other elements on top.

BASE

⊙ The voice is one of the bard's most valuable instruments, so a bigger, teardrop-shaped head creates a good contrast against the rest of the body, and allows us to focus more on the character's face. The angle of the pointed teardrop shape helps to define the rough position of the chin.

⊙ Triangles also work well for sketching and positioning the legs. Try to make them longer or shorter to see how this influences the silhouette, and make sure that the bard has a solid stance.

⊙ Use an inverted triangle to create a striking contrast between the slim waist and the wide shoulders. This puts the focus on the area between the head and the arms, which is the most important for this character.

LINES

⊙ By refining the head shape, adding the ears and two crossing lines on the face, we can define where the character is looking. Making him look up suggests he is telling stories of glorious days.

⊙ Contrast straight lines with dynamic angles to create a more interesting image and to add three-dimensionality to the design. For example, the long, straight line on the side of the bard's body gives him a solid stance, while the angles of his raised arms and leg make the pose more exciting.

⊙ As we have not yet designed the instrument, the position of the arms is still subject to change, so the hands are only sketched in roughly. Making one arm influence the character's silhouette more than the other – in this case, the character's left hand – is a great way of creating a dynamic image.

BUILDING UP

Now you can begin to add the important elements that make the character feel like a bard. While keeping the shapes in the thumbnail in mind, use some of the elements studied in the research stage to "dress up" the anatomy sketch. Draw the biggest shapes first, as they define the overall shape the most, and then add smaller elements until the design feels balanced and clearly readable.

◉ Imagine how the bard's body influences the shape of the cape. You can use almost vertical lines to show its weight below his arms and shoulders. A single round brooch holds the cape together, which you can place asymmetrically to further push the overall shape.

◉ The legs and cape consist mostly of triangles, so adding some round, thick sleeves keeps us from overusing angular forms. It helps a lot to look at references here to make the loose material look believable and dynamic.

◉ The facial expression is the key to the design. It defines our bard and shows what kind of story he is telling. Stay simple and rough at this stage – a few shapes for the main features are more than enough. His open mouth is essentially a triangle.

◉ The cape creates a big, bold shape, and to enhance this, use details such as a belt to separate the character's body into smaller forms and segments. Having a hierarchy of large, medium, and small shapes makes a design interesting!

◉ The rocks are only here to support the pose, and should not take too much attention away from the bard, so use very simple forms to draw them. By making them point towards the bard, we amplify this focus even more.

DESIGN FOCUS

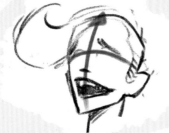

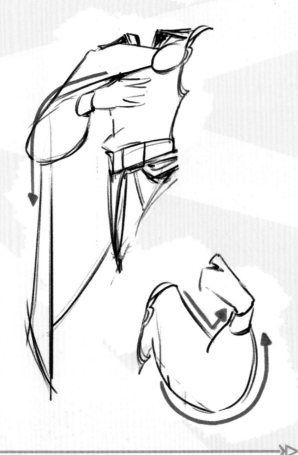

FACE › To make the character look up, we need to draw two lines: one vertical and one horizontal. The vertical line is the center of the face, and the horizontal line is where we will place the eyes. As we are not showing the face from the front, these lines need to be quite rounded to show the curve of the head. This will help to make the character's face look three-dimensional.

CAPE › The cape has a lot of weight to it, and its shape is heavily influenced by the body of the character. Try to imagine how the material behaves behind the arm. It helps to test this yourself with a blanket or something similar in front of a mirror.

SLEEVES › The sleeves in this design are round and thick, but bend easily. This means that we can use a round line to draw the lower part of the sleeve, and an angular line to show where the arm bends the material. Make sure to leave some space between the sleeve and the hand, so the two are clearly distinguishable.

IDEA INVENTORY

HEAD > As mentioned before, the head is one of the most important parts of the design. There are many different ways to make the bard look interesting, such as adding a hat, decorative elements like feathers, or even hairstyles.

In this case, a hairstyle with flowing shapes feels fitting, giving him a jaunty, debonair, and youthful look, but a fancy hat would work just as well.

INSTRUMENT > The thumbnail the design is based on shows the bard playing a guitar-like instrument. Playing around with different shapes and sizes will help us to find the instrument that really feels like it belongs to the character. Keep the overall design of the character's clothing in mind while designing this, as it helps to find the perfect one!

This instrument has a fairly small, simple body that will not become distracting when placed near the bard's face and patterned clothing.

FINAL SKETCH

Now that you have designs for the instrument and haircut, you can add both, and redraw the arms in the correct position if needed. Erase all the guidelines, and lighten the remaining lines if necessary, so everything can be erased after inking if you are aiming for a really clean final image. You can also use this stage to plan out shadow placements, working out what will be solid black ink and what will be shaded in color.

◉ Emphasize the character's pose with a light source from above. Imagine how the different elements cast shadows onto each other, and draw dark areas only where elements directly block the sunlight. This creates an appealing, graphic look.

◉ Rather than drawing each individual finger, try to apply the same shape logic that was applied to the rest of the design, drawing shapes that contrast with each other. Try grouping fingers so that they create a simple shape, as you can see on the hands here.

◉ By adding some moss, grass, and flowers, you can give more information about where the character is standing. Keep these light and simple, as you still want the viewer's attention to be focused on the bard.

◉ To create a clean and readable image, it is a good idea to draw the thickest lines around the outside of each individual shape. This ensures that the major shapes are distinct and legible after the finer details are added. Do not hesitate to draw lines over and over until they feel right.

INKING

Once you are happy with the final pencil sketch, it is time to ink. This can be done on top of the sketch if the pencil can be erased easily. If not, you could scan the sketch and print it with really low opacity, or even work digitally directly. If you are inking on paper, all you need is a thin black waterproof pen or fineliner, and you are good to go!

⊙ Start with the biggest shapes first, just like we did during sketching. When you are happy with the overall contours of the design, you can move on to carefully adding smaller details like scratches and folds.

⊙ While inking, make sure that you simplify and smooth out all the lines of the sketch. You can get rid of most of the imperfections that happen during sketching, but keeping some of these can work just as well, if that's the style that you prefer.

⊙ Be careful when drawing and filling in the dark shadow areas with ink. If there are too many of them, the illustration will look too dark, which makes adding colors much harder. Leave out areas like the inner side of the cape, so you can paint a shadow that is not black later.

⊙ Simpler, larger elements like the boots can be outlined with darker, thicker lines, while finer, less relevant objects like the flowers and belt only need thin outlines. Again, this creates focus and improves readability for the more important areas of the drawing.

COLORING

The character's pose and facial expression make him look as if he is singing a song about glorious and happy days, further emphasized by his fancy clothes and the flower behind his ear. To push this feeling even more, try using a colorful blue and yellow palette.

◉ To show that the sunlight is hitting the character, use bluish tints in areas where the light is not falling directly on him. This creates cool shadows, as if cast by complementary warm sunlight. Think of the design in terms of solid, one-colored shapes to achieve a comic-book look.

◉ Desaturated blue and brown help to balance the brighter colors, so the overall effect is not too garish. These darker colors help to emphasize the overall silhouette. Try to think of the colors as shapes in themselves, rather than gradients, to create the most visual impact.

◉ While most of the colored surfaces are separated into darker or lighter colors, you can use a third, even brighter version of the color in some areas. This indicates that an element is more reflective or is hit by more light, such as the cape's metal clasp.

◉ Create contrasts by using multiple colors in some areas and single colors in others. The cape and pants, for example, are big, legible shapes with plain colors. Using variations of these colors (such as the cape's blues), can make the design more interesting while still being subtle.

RANGER

BY MARION KIVITS

In this tutorial we will be creating an elven ranger, exploring the classic fantasy archetype of an agile, bow-wielding character who lives close to nature and navigates the woodlands and wilderness with ease.

The character's design will draw inspiration from organic plant-like shapes, as well as equipment used by real-life archers. A color palette of greens and browns will give her an element of camouflage that fits a wild outdoor setting.

TOOLKIT

- 0.5 mm mechanical pencil
- Putty eraser
- Water-resistant calligraphy pens (one hard and one soft tip)
- Watercolors or colored markers (see page 119 for color palette)

RESEARCH

Let's begin by finding some real-world references and sources of inspiration for this character. The ideal balance is a blend of classical archetypes with one or two more unusual points of reference, giving the final design a unique or unexpected touch.

ARCHETYPE › The first thing to research is the subject, of course. A ranger is a classic fantasy figure and you need to know what exactly makes one recognizable: accessories such as a bow and arrows, and physical qualities such as stealth and agility.

ART NOUVEAU › Whenever possible, try to add something personal to your work. There are a lot of Art Nouveau facades in Belgium, where I live, and I want to incorporate this into the costume, maybe in the form of ornate headwear. Personal touches like this make your designs more unique.

BOW › Most rangers use a ranged weapon like a bow or crossbow, so try to explore some different shapes and options. This bow was used by ancient Mongolian archers, and was not too big, which fits well in a forest setting where a lot of branches and plants can impede movement.

ARMOR › Explore what other equipment archers might use. They might need to protect their forearm from the friction of the string, or use a chest guard. Chest guards are mostly used for bigger bows, but they also help to keep the archer's clothes out of the way.

KNIFE › Rangers are hunters, and hunters need a trusty knife. Drawing more inspiration from the Mongolian bow, here are some Mongolian knives. They are simple in shape, and some of them include a flint and tinder pouch – very practical in survival situations!

THUMBNAILS

Consider thumbnails as simple notes on a given subject. This removes a lot of the pressure of drawing them perfectly, though you should try to keep them as clear as possible. Begin by drawing the first ideas that come to mind, and then start asking yourself "What if?" questions. Try to imagine what the life of your character is like. For example, "What if they lived in a tropical forest?" or "Do they live in the forest all the time, or do they go home to the city?"

CHOSEN THUMBNAIL

Thumbnail 8 is a strong choice for its clarity and simplicity. It shows the character's face, clothes, and weapon clearly. However, the bold triangular cape in thumbnail 7 is a great feature that ties in with the character's arrow-related theme, so that could be incorporated into the design too.

FOUNDATIONS

We will now make sure to determine the general shape clearly, so we do not lose the dynamism of the first sketch. If you plan on using watercolors for coloring later, don't forget to switch to a suitably heavy paper at this stage. Use broad, light pencil strokes to determine the direction and movement of the character, working from the biggest forms (the main shape) to the smallest (the torso and limbs). Loosely define the cloak but do not get lost in detailing the folds, and do not think about the rest of the clothes yet.

BASE

⊙ The whole body is blocked out with ovals and rounded shapes. It helps to sketch the central lines of the head and torso to indicate which way they are facing; in this case, the character's head is turned towards the viewer while the rest of the body is in a three-quarter stance.

⊙ To create a tall and nimble character, exaggerate the thinness and length of their limbs to convey their flexibility, almost like a deer.

⊙ At this early stage, aim to determine the general movement of the figure. Your research will help with depicting how an archer stands and holds a bow, as well as the position of their arms. Do not add the bow yet, though.

LINES

⊙ The character should have no clothes at this stage, but you can sketch in the loose flow of the cloak, and block out the shape of the bow. The bow basically consists of two curves that flare outwards at the ends and are joined in the middle by a flat central grip.

⊙ Keep in mind the height of your gaze. From the "camera's" point of view, are you standing at the same level as the character, or are you looking from above or below? When the image is more about showing the costume and stance of the character, like this one, it is easiest to imagine you are standing in front of them and looking at eye level.

⊙ Sketch in a light suggestion of a hood around the character's head, with a clasp at the chest where it fastens to the cloak. The rest of the outfit details will be built around these main shapes later.

BUILDING UP

For a character archetype like this one, you need to make sure the viewer can guess their role at a glance. The aggressiveness of the triangular, arrowhead-like silhouette will be softened by adding organic shapes, enhancing the ranger's feeling of belonging to the forest. This stage should also draw inspiration from the research and other thumbnails, incorporating ideas such as the leafy cloak one thumbnail had, as well as the Art Nouveau elements.

◉ At this stage the life your character leads should be clearer and reflected in their costume. An elf has long ears, so a full hood could be annoying; instead, this hood has slits in the sides. Running while wearing a hood could also be quite difficult, hence the diadem (a type of crown) to hold it in place from the inside.

◉ If the elf will be wearing a piece of jewelry, why not make it a magic medallion with roots wrapped around it? These roots can be featured throughout the design to create a coherent look.

◉ The shape of a bow can vary a lot, from an "at rest" pose to a loaded weapon. In this case, the string is in a resting position, pulled straight between the two ends. You can use a ruler to lightly sketch it in.

◉ Do not make the cloak too busy with leaves, as that would make the sketch too confusing. Instead, indicate them lightly with a few triangles along the hem, and more around the character's shoulders to draw attention to the upper body and head. You can then contrast these textured areas with very simple clothes.

◉ Combining the elements of leaves and Art Nouveau gives me the idea for a web of living roots that wrap around the ranger's body, perhaps increasing her power.

DESIGN FOCUS

BOW ARM > To build a shape that effectively supports movement, studying comes first. Find some pictures of archers in action, simplify the shapes of their arms, and exaggerate the lines to clarify the direction of the gesture. It is important to show where the strength of the arm pushes, and how the hand wraps around the bow shaft in an angular, blocky shape.

FEET > For the overlapping leaves on the lining of the elf's cloak, the key is again to simplify. Start by lightly placing triangle shapes, and then indicate where the leaves cast a shadow, to clarify which object is in front of which. You can experiment with regular patterns or more organic, chaotic ones. Once you are satisfied with their placement, you can work more complex shapes and distortion into the leaves.

LEG > To draw convincing roots, you have to keep in mind the shape of the object they wrap around, and the shapes of the roots themselves. As always, let's simplify. Take note of the shape of the leg (a cylinder, basically), and wrap simple lines around it. Once you like the position of the lines, you can add volume to make them into small, cylindrical vines. These are the perfect map for adding details, textures, and maybe a leaf here or there.

IDEA INVENTORY

MEDALLION > One of the elf ranger's main accessories is the medallion. With Art Nouveau and nature as inspirations, sketch different shapes, exploring where the power could come from.

The jewel could be called "The Heart of the Forest," with something close to a heart shape, as it also fits with the character's triangular shapes.

KNIFE > The knife is a secondary object, but it is important to show that it belongs to this character and no one else. It could be wrapped in roots like the ranger's body, which keep the knife in place, only releasing the blade at the elf's will. Sketch some test designs built around simple lines of action.

This fairly straight blade, without a large hilt, is quite similar to the Mongolian blades from the research stage.

FINAL SKETCH

If time allows, try to take a break before this step, as it will give you more clarity and help you to spot any mistakes. When you return, use a kneaded eraser to fade out the messy sketch. It is counterproductive to be too focused on the drawing's quality in the earlier stages, so save that for this final sketch phase. With the uncertainties now removed from your mind, you can focus on making better lines and correcting any mistakes in the anatomy or design. Use light, faint strokes for peripheral areas such as the hem of the cloak, and focus more detailed lines and shadows in key areas such as the head and chest.

○ Now that most of the patterns have been decided in the Idea Inventory phase, you can repeat them in other parts of the design, such as her bow. Repeating small motifs like this helps to tie the whole design together.

○ The roots on the ranger's arm are also important, giving her more strength for archery. To enhance that fantastical "merging" aspect, as if they are part of her body or clothes, I decide to have them fade away in the shape of a glove.

○ The root motifs here are drawing inspiration from the research into Art Nouveau. Keep your hand relaxed when you draw organic shapes like these. If you are too stiff or clenched on the pencil, you can end up with sharp, mechanical lines.

○ Draw more attention to the roots by removing half of the elf's top, which is reminiscent of the chest guard from the research stage. This also makes the medallion more visible.

INKING

My main advice for this stage is, "Stay calm!" Do not rush the inking or you might end up spending more time fixing mistakes. Instead, take a break and come back refreshed. For the first pass, you could use a calligraphy pen with a hard tip; it will prevent you from making the lines too heavy, and it still has a bit of flexibility for line weight. Do not ink most of the leaves – the results would be far too busy for a drawing of this size. You can suggest the leaves during the coloring stage instead.

◉ You can use a ruler to draw straight lines, like the bowstring, but you can also draw them by hand if you are feeling confident. The trick is to look at where your pen is going, not where it is!

◉ Hatching is a good way to indicate volume. Keep the bigger shapes in mind though, because too much hatching can make a drawing very cluttered, especially if color comes into play afterwards.

◉ The face is a delicate part because it is one of the most important visual elements for humans. Do not become too enamored with it though, because adding too much detail can break the balance of a drawing. Keep it slow and step back often to evaluate the whole.

◉ Imagine the roots as cylindrical in shape, and add strokes that twist around their surfaces to create a woody texture. When adding lines and hatching, such as to the robe and hood, try to create a flowing look by following the direction of the fabric with your strokes.

COLORING

Watercolors can be intimidating because of their translucent nature, but over the years, whenever I need a portable solution to add color to my drawings, I always come back to them. They are a quick way to add simple indications with flat tints, which is why I stick to simple washes and mostly rely on the ink for the details. You can achieve the same translucent quality with colored markers, building the layers up gradually from light to dark.

⊙ Rangers often wear green cloaks. You could go for a different color, but since this is an archetypal representation, green it is! Leave the colors light and translucent towards the bottom, so the cloak is not too visually heavy. Dab more layers of green where shadows are needed.

⊙ Stay simple to avoid colors becoming muddy. Once you have chosen your main colors (bluish desaturated green, bright red, and light neutral brown), apply light amounts over the appropriate areas. Avoid areas where the light hits, and add more layers to build up shadows and color variation.

⊙ Take your time when choosing colors. Do you want a complementary scheme, triadic, or analogous? The complementary scheme is well-known and effective, so cool green would work well with warmer reddish hues.

⊙ To keep the character balanced, find a neutral color (in this case, a light brown) and use it for the "filler" elements of the design. The main color here is green, with red to attract the eye to important elements of the design, and the neutral brown helps to fill out everything else.

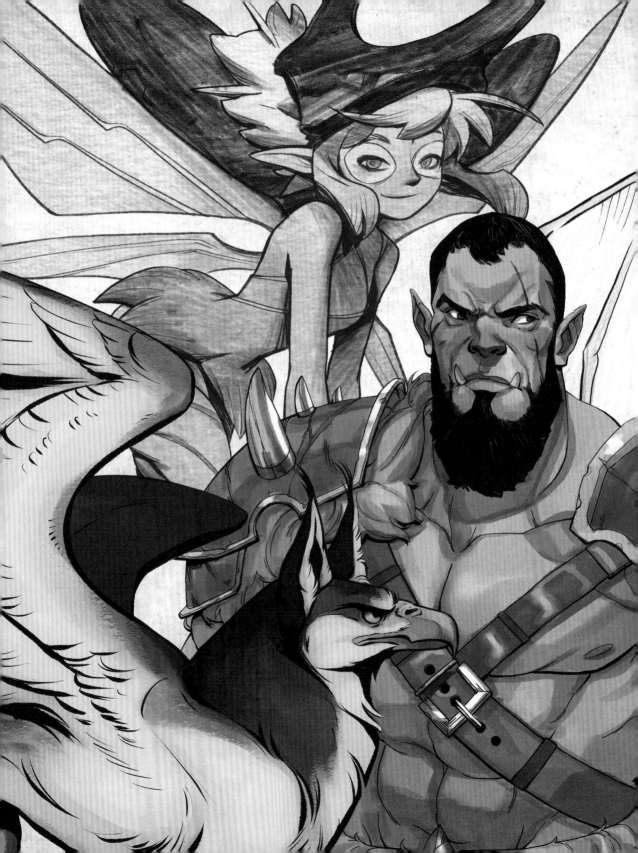

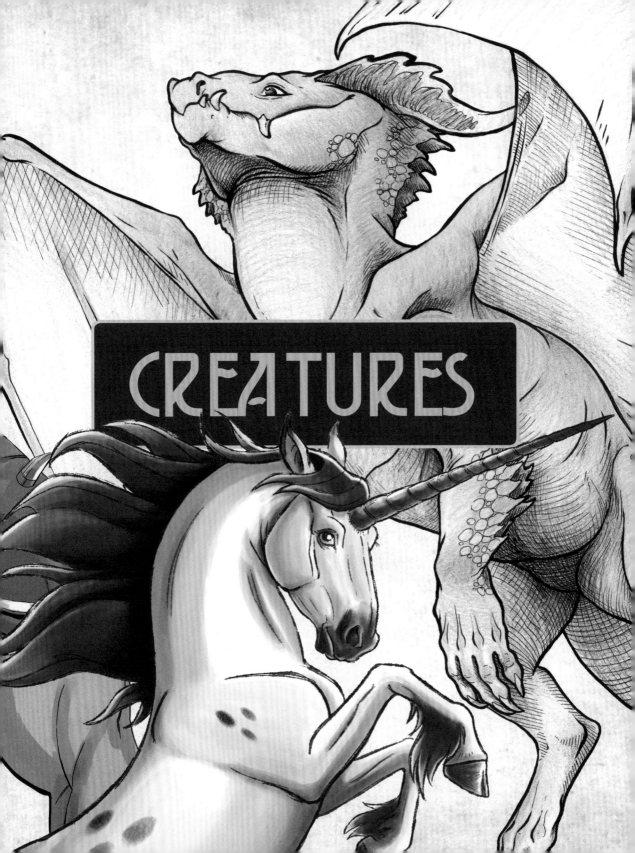

CREATURES

DRAGON

BY AUDRE "CHARAMATH" SCHUTTE

In this tutorial we will be drawing one of the fantasy genre's great staples: the dragon! There are many ways to depict dragons, but we will be going for the archetype of a giant reptile with four legs and bat-like wings. Referencing the anatomy of real-life animals will add believability and inspire subtle details such as horns and scale patterns that will give life and depth to the design.

TOOLKIT

- ⊙ Red erasable pencil
- ⊙ Graphite pencil (such as HB or 4B)
- ⊙ Kneaded eraser
- ⊙ 0.3 mm black fineliner pen
- ⊙ Black brush pen
- ⊙ Colored pencils (see 131 for color palette)

RESEARCH

Beginning with a classic dragon design like this helps in two ways: it's easier to get a clear mental image of the creature, and there are a lot of real examples in the animal kingdom that we can look at for reference. Reptiles, goats, bats, birds of prey – all are worth looking at. If the search for references seems overwhelming, try narrowing your subjects down to animals that live in climates similar to the one you picture your dragon living in.

BAT › Bats' wings are excellent reference for the leathery wings of a dragon. Notice how there are flaps of skin not just between the "fingers," but also along the leading edge of the wing.

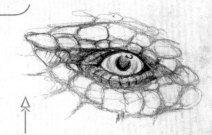

SKINK › The design of the eyes and the scales around them would be strongly influenced by the dragon's environment. This eye belongs to a variety of skink (a type of lizard), with a heavy brow that shades the eye.

GOAT › The variety of horn shapes in the animal kingdom is astounding. Some are decorative, some are for combat, and many are both. This particular horn is from the endangered markhor goat, and could inspire an unusual spiral horn for our dragon.

CROCODILE › Crocodiles and alligators provide excellent reference for heavily scaled limbs. Their anatomy is better evolved for swimming, but you can use the scale patterns to influence your own design.

RAPTOR › The feet of birds of prey (also known as raptors) are great to look at for both scale design and talon ideas. You may also find it helpful to research how their feet clutch prey, to see how their talons work in action.

THUMBNAILS

When drawing thumbnails, focus on readable poses. This means that you should be able to tell what the subject of the drawing is doing even at a distance. These thumbnails are about the size of a thumbprint – you can hold them at a distance to test their readability. Focus on dynamic poses that really showcase all the elements of a classic dragon, such as the wings, head, and limbs.

CHOSEN THUMBNAIL

Thumbnail 2 is both clear and dynamic. The wings offer different angles and the head is set up well to give some personality to the final piece.

FOUNDATIONS

When going from your thumbnail to starting your main sketch, it's best to start off with a light touch. Use an erasable colored pencil (such as a red animator's pencil) to lightly block in the major forms with geometric primitive shapes. "Major" forms are typically the parts of a character that anchor it and affect the "lesser" forms if moved. Once you are happy with the basic shapes, begin lightly outlining the dragon by bridging the shapes in graphite.

BASE

⊙ One of the first things to do is to draw a "line of action." This line helps to keep you on track while you flesh out the rest of the shapes. In this case, the line of action flows down the dragon's neck and spine to its tail.

⊙ The rib cage sets the scale for the rest of your pieces. Use an elliptical shape to create it. Next up should be the kite-like box shapes for the hips and shoulders.

⊙ The framework you use for the head will vary. Rounder shapes will create softer faces, and more angular shapes will create aggressive ones. A square, blocky frame such as this one suggests a strong, reliable personality.

LINES

⊙ The basic shapes you drew in red are more guides than exact measurements. Don't be afraid to draw outside or within them to get the correct shapes for areas like the major leg forms. In this case, add some curves for leg muscles and block in circles for joints.

⊙ Unsure of how to space out the sections of the wing? Use your spread hand for reference! Wings are surprisingly flexible, so their "finger" positions can vary a lot. Draw the wing membranes with swooping curves and four sharp points for the wings' "fingertips."

⊙ Resist the urge to draw all the fingers and toes right away. Instead, focus on getting the poses of the hands and feet down first using broad shapes and guiding lines for the joints to help with perspective. Here you can see how curves indicate where the knuckles will be, and how to group most of the claws together in distinct blocks.

BUILDING UP

Even for a simplified, stylized concept, a strong basis in real anatomy is key. Think of it as knowing the rules before breaking them. This stage is all about developing the final shapes and forms before you move on to fine details. Think about how your dragon moves. What forms does that movement affect? Are there similar real-world examples you can look at for help?

⊙ Add in some faint shapes for the more decorative details of this dragon, such as the bony ridges on its head. These details will be fairly prominent later, so it's important to rough them in now to make sure everything is still balanced.

⊙ At this stage, start thinking of the prominent anatomy features that form the medium-sized shapes of the creature. For example, the wings anchor to the bottom of the breastbone, which is called a "keel" in bird anatomy and creates a prominent bony ridge.

⊙ Add another circle between the rib cage and hips to lend weight to the dragon's belly, giving it a solid, muscular middle. A dragon fresh from a feast would have considerably more paunch here.

⊙ Wings are easier to draw when you focus on where the joints are before you start drawing the long bones. Treat the wings much like you did the hands, placing the "knuckle" joints and trying to maintain a strong overall silhouette.

⊙ The hands and feet of this dragon are heavily inspired by birds of prey, featuring large, hooked talons. This makes sense for a big predator that probably snatches up prey and flies off. Add individual fingers and toes within the blocked-out shapes.

DESIGN FOCUS

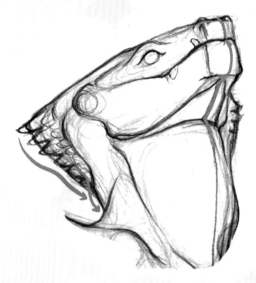

HEAD › Getting the correct perspective on a head can be very tricky, but this blocky, rectangular shape makes things a little easier. Add a center line to help you keep the facial features in line. If you find yourself getting stuck, try to "sculpt" a loose physical model of the head out of your kneaded eraser. Use that to figure out the correct angles on your drawing.

NECK › This particular dragon boasts a wide neck with many overlapping forms. The forms of the neck join into the shoulders with an overlapping triangular shape, and the thick lower jaw overlaps the neck muscles in another triangular shape. Along the back of the neck, the rows of scales join together not in straight lines, but more like ripples that get progressively larger.

FEET › As mentioned before, the feet of this particular dragon are heavily based on birds of prey. Besides the large talons that give superior snatching skills, these feet also sport thick pads that cushion the bones, a little like a very bulky version of your big toe! Lightly draw in circles where the joints are, so that you do not accidentally miss any digits.

IDEA INVENTORY

HORN > When it comes to horns, the possibilities are endless. When deciding on a final design, you need to consider two things: why does this dragon have these horns, and do these horns "fit" the dragon's character?

This jagged horn, a combination of the two other designs, is a strong final choice. It's functional and sleek with distinctive ridges.

SCALES > Scales can also vary in function and form. If you think back to the research stage, you'll remember that crocodiles have thick scale ridges along the outer edges of their limbs. Try to design several scale ridges playing with that idea.

For a coherent final design, go with the jagged scales that pair best with the dragon's horns.

FINAL SKETCH

Erase the previous lines and guides and redraw a cleaned-up version with a softer pencil. The softer graphite allows you to apply more line weight to the piece, and erasing the previous lines makes it easier to add the traits chosen in the Idea Inventory. You can also use hatching (shading with a series of lines) to start adding shadows, planning how to make the final piece more dynamic.

◉ For the mouth of this dragon, look again at crocodiles. Their overlapping teeth poke out of their mouths even when closed, so give the dragon some of these. Extend the line of the dragon's mouth far back along its head to hint at a massively wide bite.

◉ The textured scale ridge from the Idea Inventory doesn't just appear on the forearms – it is echoed throughout the design on the neck and tail. Without repeating design details, the forearms might come across as out of place.

◉ The skin of the wings is stretchy, creating areas with little folds or ripples called "tension marks." Adding a few of these enhances the impression of the wings having flexible membranes.

◉ Experiment with shading now before you start to ink and cannot erase. Start lightly and build up slowly, following the flow of the anatomy with your hatch lines.

◉ Don't feel pressured to draw every single scale. That would just make your image look cluttered. Instead, add a few scales in prominent areas (such as the head and limbs) and the dragon will still come across as "scaly."

INKING

For the inking stage, use a brush pen or a thick fineliner for the outlines of your piece. Foreground elements will typically have thicker outlines, while background elements have thinner outlines. This draws the eye forward and gives a natural sense of depth to your subject. Line art skills take practice to develop, so don't be disheartened if you do not get everything perfect. It is a good idea to take a photo or scan of your piece before inking it, so you can try again if you make a mistake or would like to try a new approach.

⊙ Do not heavily shade areas like the outer wings or the end of the tail, as we do not want them to be too dark or heavy. You can imagine the foreground wing catching the brightest light as the dragon takes off, so avoid shading it at all.

⊙ Using your thin fineliner pen, start hatching in an area you know you want to be dark (like an armpit), just in case the line turns out heavier than expected. For areas of darker shadow, you can add more layers of hatching, or hatch with lines that are tighter together.

⊙ A thin fineliner helps to capture delicate details like the round, pebble-like scales. A few clusters of these are enough to convey the dragon's tough hide. The throat and underbelly are left scale-free, with the hatched shadows suggesting a smoother texture.

⊙ Outlining the whole piece before going into the finer details can help you balance out the line work. Make sure to leave plenty of time for the ink to dry before starting the finer details to avoid smudging, especially if you are using a brush pen which can leave quite a wet line.

You can use colored pencils to bring the dragon to life in this stage. Since this dragon is fairly classic in appearance, you can go with a classic color – green! However, not just any shade of green.

This dragon could be resting on a hill among rolling green fields, perhaps casually eyeballing some sheep. A grassy green would help this dragon blend into those hills and avoid notice.

This color scheme also adds a light touch to a type of creature that is often depicted as dark and menacing.

◉ Start with the lightest colored pencils first and build up to the darkest with careful layers. Don't apply too much pressure or you will lose your ability to layer over that area afterwards.

◉ The ink hatching has already set up much of the shading, but to help it along, shade the dark areas very softly with burnt ochre and dark blue. The subtle blue touches suggest a reflected outdoor light, as if the dragon is flying against a blue sky.

◉ Though the dragon is green, fill out the entire piece with light gold and olive colors first. This helps to set the warm base tones for the final palette, and adds more depth and nuance than simply applying one color.

◉ Add the green towards the end of the process: once before the shadow colors are added, and once again after, to blend the colors smoothly. It is only with the final layer of green that you should start to apply pressure. Finish the horns and eye with the ochre and blue.

UNICORN

BY MARIA WEJS HENRIKSEN

In this tutorial we will be drawing a unicorn that has a traditional horse's features and a few magical twists. It will have a classic white coat, but a fiery red mane and some deer-inspired details that will add personality and make this design stand out. A semi-realistic style will give us the chance to explore the challenges of horse anatomy, while a striking pose will add some stylized drama to the final image.

TOOLKIT

- Graphite pencil
- Eraser
- Ink pen
- Colored markers (see page 141 for color palette)

RESEARCH

When inventing a creature, it is important to study real animals that share a close resemblance to it. It is easier to create a hybrid creature such as a unicorn after studying similar subjects and animals. A horse has complex features that can be especially tricky to draw, so by studying horses, and other useful references such as horns from gazelles, you will understand more about what you are dealing with.

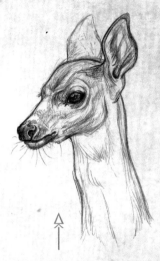

HORNS > Horns can have very complicated structures, so it's helpful to familiarize yourself with various horn types early on. The frills and dents of a Thomson's gazelle's horns could be intriguing to use.

DEER > A deer-inspired unicorn would be less bulky than one based on a horse, with a longer neck and more slender physique. These qualities could make the unicorn look more ethereal and graceful.

HORSES > There is no classic unicorn without the study of real horses! To familiarize yourself with the overall shapes and features, it is important to study subjects either from life or at least from many different angles if using picture references. It's the best way to practice understanding mass and form.

HOOVES > Unicorns can incorporate features from other beings of your choosing, such as other hoofed animals. A unicorn-deer hybrid could be another interpretation, with a deer's cloven hooves instead of the continuous solid shapes of a horse's hooves.

THUMBNAILS

This design needs an appealing pose with a clear silhouette that conveys the unicorn's personality. Start by deciding what personality you want the creature to have, writing down keywords such as "wild" or "fiery," then base the shapes on those ideas. Our first ideas are rarely the best, so it's good practice to fill out pages with as many poses as we can imagine! These thumbnails explore a range of different shapes and horns; some look small, shy, and deer-like, while others have more robust, classic horse-like proportions and features.

CHOSEN THUMBNAIL

The rearing unicorn in thumbnail 6 will have a clear silhouette when seen from afar, and will give the creature a striking dramatic effect.

FOUNDATIONS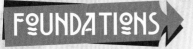

Basic geometry will help to translate a loose doodle into something more tangible. Shapes should be applied in order of "small, medium, large" to create a visually interesting, varied design. Though this unicorn is wild and fiesty, we do not want it to look scary or dangerous, so keep in mind that sharp shapes can look evil or harsh, while rounder shapes have more pleasant associations. This "skeleton" will make it easier to correctly place the features, which is especially useful for a creature like a horse that has very distinctive, often challenging anatomy and mass.

BASE

⊙ The barrel-shaped cylinder belly informs us of the rib cage underneath, and creates the solid bridge-like structure that horses naturally have. Draw a big cylinder to connect the circle of the hip to the chest part.

⊙ Simple circles indicate the volume of the head, so you can see if it fits with the overall body. Place one circle for the top of the head and a smaller one for the end of the muzzle, and join the two together to create the basis of the head.

LINES

⊙ Soften the sharp edges of the geometry with organic curves, slowly phasing out the geometric lines to connect all the separate individual shapes into "one." See how much more natural it already looks!

⊙ To define the front of the head, start from the biggest circle on the head, draw a diamond shape where the unicorn's forehead will be, and connect it to the eyes and all the way down to the muzzle. Always check your research and references to make sure the perspective looks correct.

BUILDING UP

It is tempting at this stage to draw all the details right away, but try to stay focused on the most important features. Start by adding curve and volume to the flat geometry, along with figuring out the perspective with the help of research and references. A creature has weight, so making it look balanced and grounded is important. Imagine this as the "building block" stage of the image, where you are only drawing the biggest features.

⊙ The eyes should be placed solidly in the head to avoid the mistake of "floating" features. To do this, make sure you sketch out the eye socket and eyelids as well as the eye itself. Eye reflections are not necessary yet – just outline the eyes so you know where to place the details later.

⊙ The mane's shapes can be used to guide the viewer's attention towards the face or other parts of the image. The mane should reflect the character's unearthly, untamed, and magical abilities, described in flowy shapes.

⊙ This unicorn has a plume of hair on the end of its tail, different to that of a horse. Draw a pleasing, flowing shape for the outline of the hair, which you can add finer strands to later.

DESIGN FOCUS

HORN > The horn is vital to any unicorn design, providing the creature with a silhouette that instantly reads "unicorn." Draw a simple cone shape, and then draw down the length of it with a looping line indicating the spiral groove. Erase the lines that would be hidden on the back side of the horn, so only the foreground spiral lines remain.

HEAD > Think of the head as a diamond shape that tapers off to a point at the muzzle. From the top of the head, draw a line connecting down to the nostrils. Then with more angular and straight lines, draw the cheekbone beneath the eye and indicate the prominent jaw, which is a very clear landmark on any horse.

HOOVES > Hooves can appear to be very complicated and hard to make look natural, especially when seen from a tricky angle or when bending. It is a good idea to study them from anatomy books or pictures, and practice breaking them down into simple geometric shapes such as tubes, squares, and circles. See geometric breakdowns of more hooves on the next page.

IDEA INVENTORY

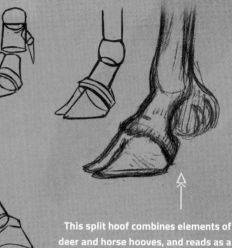

HOOVES > A traditional horse hoof can work for any unicorn design, but could be a bit too simple for this more fantastical design. Cloven hooves give the impression of a light, graceful, forest-dwelling creature, and could perhaps be well-suited for a smaller, leaner unicorn design. When choosing an element to add to a design, it is important to decide if it fits into the overall story and personality of the animal. The sky is the limit for what combinations can be made with all these elements!

This split hoof combines elements of deer and horse hooves, and reads as a forest creature while still carrying the underlying feel of a classic horse-like unicorn. If you have trouble drawing something at first, try to break the complex and confusing shape into very simple boxes and cylinders.

HORNS > For the horns, look at a mix of traditional and more unusual horns. The first version is almost branch-like and more unusual than a classic spiral horn. It would make the unicorn feel like a magical forest-dweller, perhaps an older creature that has a combination of wooden and forest-like design elements. The narwhal-like central horn reads instantly as belonging to a traditional unicorn, as we would know them from art and stories. The third horn is a combination of a Thomson's gazelle horn and a traditional unicorn horn – a very natural and unique-looking horn, but one that would perhaps suit a more realistic style and a smaller, feistier type of unicorn.

The unicorn needs to look beautiful, mysterious, and also easily recognizable, so this horn will be the right fit for this design. You can use a simple cone shape to draw it.

FINAL SKETCH

Now the elements are ready to be put together. The classic horn and split hooves from the Idea Inventory will work best for this design; they are somewhat familiar, reminding us of a horse, yet with some mysterious and magical qualities that are not quite earthly. Take extra care to get the proportions and perspective right, and of course to check if the overall design reads clearly without becoming confusing or "busy" with details. It is helpful to mirror the image by flipping it on your computer, with your phone's camera, or by holding the drawing up to a mirror to spot mistakes. It is also important that the overall shapes flow with each other and do not appear like separate entities.

⊙ As mentioned in the Idea Inventory, narwhal horns are a great inspiration and reference for this horn. Make sure to wrap the strokes around the conical shape of the horn to create a believable spiral.

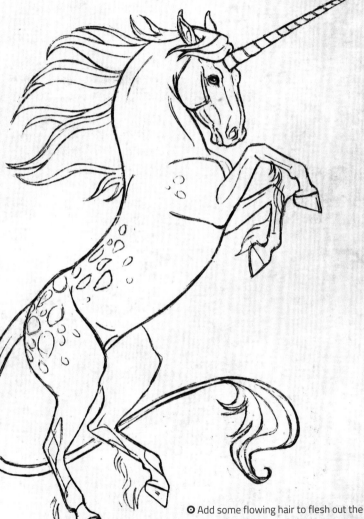

⊙ Add some spots to enhance the personality of the creature as well as creating an interesting visual. Make the spots curved so they do not appear flat, seeing as the unicorn is a three-dimensional creature.

⊙ Add some flowing hair to flesh out the mane, tail, and legs, but do not make it overly detailed or it might become too visually heavy and distracting.

INKING

Inking can be done in a variety of ways, whether traditionally with pen and paper, or with digital tools if you scan your drawing. Whatever tools you choose, you should aim to use your shoulder to draw broad ink strokes and achieve smoother lines. Make the strokes thicker when a limb or object overlaps another – this is a good way to make things "pop" out of the image.

⊙ Draw scratches on the horn to indicate a hard, polished surface material. Make sure these follow the shape and volume of the subject, so the results do not look flat. You can see these scratches are slightly curved to follow the convex surface of the spiral.

⊙ As with the unicorn's horn, use a fine pen to add some thin lines to the hooves to give them the appearance of a hard, slightly worn surface.

⊙ Ink the mane with no sharp edges, and shapes that are less angular, to give it a softer and more recognizable "hair" feel. Even for a design that is quite stylized and not fully realistic, like this one, it's important to clearly distinguish shapes and textures.

⊙ It is not too late to make some small tweaks to the design. In this case, the number of spots is pared down so that the final colored design will look cleaner and simpler.

Before coloring, we must decide which angle the light source is coming from. In this case, go for a simple scenario with the light coming from the upper right side of the image. Using markers, start applying the light colors first, and slowly add layers, blending up to the darker colors. To make the color palette cohesive, relate the colors back to each other by adding some red from the mane into the muzzle and hooves. The red and white palette combines a very classic unicorn look with a more unusual fiery side.

⊙ To portray an elegant creature with a coat that looks smooth and soft, keep your marker strokes and layers even and consistent. Use a light marker to build up layers of color, rather than jumping straight to a medium-toned marker. Markers are a great tool to practice softening the edges of colors.

⊙ It is a common mistake to think that shadows can only be black and grey, especially on a white surface. Shadows can reflect colors that bounce up with the light from the ground, from the creature itself, or from other objects nearby. Use a range of pink, orange, and blue tones to shade the edges and forms that are sheltered from the light source on the upper right.

⊙ Manes are made of small, fine strands of oily hair, and can reflect the light beautifully. Leave areas of the white paper showing to create highlights, as you can see here, to indicate light shining "through" the edges of the mane in places.

⊙ Remember that light and color bounce off surfaces, so you can see color reflect from one surface to another. In this image, the light bounces off the white surface of the neck and highlights the underside of the jaw.

FAERIE

BY KHOA TRAN VIET

In this tutorial we'll be making a sprightly, mischievous faerie. Her clothing and accessories will draw on nature for inspiration, using insect and flower elements to give a sense of her small size and where she lives. A pose driven by dynamic lines will give the character an impression of movement and agility, as if seen in mid-flight carrying her firefly lantern.

TOOLKIT

- ⊙ Graphite pencil
- ⊙ Eraser
- ⊙ 0.1 mm black fineliner
- ⊙ Black brush pen
- ⊙ Colored pencils (see page 151 for color palette)

RESEARCH

Begin by breaking the subject into different elements, then researching on the internet for images relating to the resulting keywords. You need to research insect wings, leaves for the character's clothes, and designs for a flower lantern, as these elements will help to make the character look tiny. A rhinoceros beetle will provide the inspiration for her wings, and bringing in a beetle hat will make the design more specific and interesting. This faerie will be young and strong with a little smirk, so practicing some potential facial expressions will be useful as well.

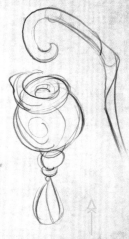

BEETLE > It would be an interesting contrast to give this dainty faerie the tough exoskeleton of a rhinoceros beetle as decoration. The beetle's horn would add a very strong shape to her silhouette.

LANTERN > The character will carry a lantern lit by fireflies to make her look friendly, and to convey that she is a curious gatherer faerie rather than a warrior. The lantern could look like it is made from twigs and petals.

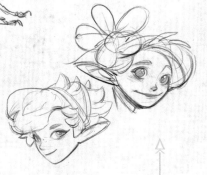

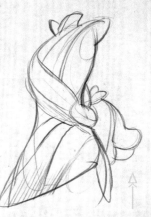

WINGS > Faeries are often depicted with big butterfly wings, but giving this character narrow, beetle-like wings will make her more unusual and dynamic.

EXPRESSIONS > This character is energetic and confident, but also quite young and dainty. Large eyes and a happy, mischievous facial expression would help to convey all these qualities.

CLOTHING > Giving the faerie a dress made from leaves or flowers will tie in with the character's nature theme. Wrapping the layers of clothing in a cocoon-like fashion will push the insectoid aspect as well.

THUMBNAILS

Experiment with as many different design ideas as you can here, such as lantern and wing shapes, and different flying poses. Pointy shapes make the character look dynamic and energetic, while rounded shapes look more friendly and harmless; both are appropriate for this faerie, but you should aim for a balance of both qualities. As you sketch, you can easily compare the options until you find the best version of the character.

CHOSEN THUMBNAIL

Thumbnail 2 is a strong choice because the faerie's pose is very clearly recognizable. It also has strong visual flow, with every pointy shape leading towards the focal points of her upper body and head.

FOUNDATIONS

Start to build up the chosen thumbnail, focusing on the character's most basic shapes. Begin by sketching loose ovals using a light colored pencil, and do not make the figure too complicated. Focus on blocking out the lengths of the limbs and finding an overall flow for the character. Once you are happy with those shapes, use a graphite pencil to round off and connect the basic shapes to create a defined figure.

BASE

⊙ Make the character's head proportionally big, so the rest of her body looks tinier. The head is just a circle for now – you will draw the neck later.

⊙ Ignore appendages and accessories such as the wings and hat for now. Focus purely on blocking out the character's proportions.

⊙ Draw one leg extended, and fold the other leg up under the character's body to create a delicately balanced pose. This will guide the viewer's attention up the figure to the head.

LINES

⊙ Now you can make the head shape more specific, establishing the character's facial expression. Sketch loose circular sockets to help place the eyes, so you can build the other facial features around them.

⊙ Add curved lines to connect the base ovals of the belly and chest together. Try to imagine how the actual figure would appear in three dimensions, and look up references if you need guidance for connecting the geometry.

⊙ Make sure the feet follow the line of the lower legs, to give the character a strong sense of direction. This ballerina-like pose will make our faerie feel delicate and agile.

BUILDING UP

Now you can start finalizing the character's design, replacing and changing details until you are happy with everything. When adding detail, it is advisable not to break out of the character's silhouette too much; make sure that every detail supports the overall shape and action. In this case, there are several diagonal elements meeting in the center of the character's upper body, so the most detail should be focused in that general area.

⊙ Add some extra hair that flows forward around the faerie's face. This bouncy, messy hairstyle will help to frame the character's face and add more motion to the pose.

⊙ The character's wings and hat are inspired by rhinoceros beetles, and you can repeat this theme elsewhere to make the design more cohesive. Do this by adding zigzag shapes on her legs, inspired by beetle exoskeletons. You can also repeat the folded cocoon pattern of her dress on her legs, to tie all the clothing together.

⊙ You want the viewer to feel the speed of the character's wings and movement, even though this is not a full action scene. Instead, the wings create a sense of action with their open diagonal shapes. Try to draw them accordingly with quick, light strokes.

⊙ To add some movement to the lantern, add a decorative tail that's angled off to one side. This immediately gives the object weight and momentum, showing the direction in which the faerie is flying.

⊙ The faerie's flower dress is a useful element for adding flow and motion to her body. Keep the lines of the dress tight around her upper body and belly, then fan the skirt outwards to create a fun, bouncy effect that matches the tension of her pose.

DESIGN FOCUS

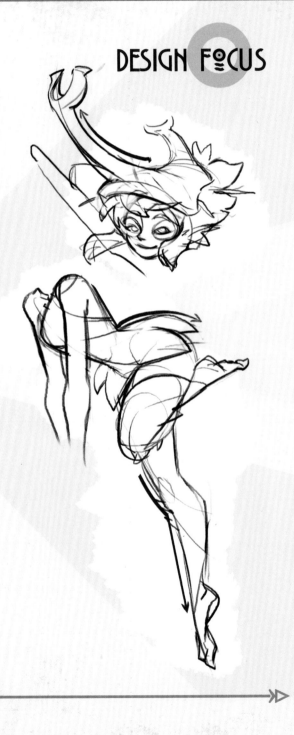

HEAD > All elements of the image should have an action line that reinforces the character's pose. For example, the strong curve of the beetle hat will help the viewer to recognize that the faerie is leaning forward. Draw the hat with strong forward-curving strokes to emphasize this movement.

DRESS > Draw the faerie's torso and dress with a mix of straight and curved lines. For example, draw a straight line leading to her waist before inflating into a curve to create the skirt. Avoid adding too many small details that will affect this clean silhouette; the character should look light and streamlined enough to be lifted by her insect wings.

LEGS > When drawing the legs, as with the dress, use a mix of straight lines and slight curves to create flow and contrast. For example, the upper leg is a curve, leading into the straight line created by the lower leg and foot.

IDEA INVENTORY

COSTUME > The faerie's clothing should look soft, comfortable, and graceful, allowing her to fly around speedily. Her wings count almost as an extra accessory, and must fit together with her whole costume, so we should try to incorporate some of their shapes and visual quality into her clothing. You could possibly put wing-like shapes at the tops of her boots, but on this occasion they might interfere too much with her skirt.

It will be a good idea to wrap elegant lines around her clothes to echo the delicate veins of the beetle wings.

LANTERN > For the lantern, you want to find a balance between organic floral details and a simple, clean silhouette. To add motion to the lantern as it swings in the faerie's hands, and perhaps because she never puts the lantern down on the ground, it could be decorated with flowing grass at the bottom. You can almost imagine it being animated!

The character already features many pointy shapes, so use the most rounded lantern to create an attractive contrast.

FINAL SKETCH

Begin erasing the basic guidelines and going over the whole drawing to refine it. As you finalize the details you are happy with, use a freshly sharpened pencil or mechanical pencil to make the lines bolder and clearer. Add details to the lantern and clothes, based on the Idea Inventory, and add a new pair of gloves so that her hands do not look too simple. However, make sure that her overall outfit is not too cluttered with details; this gives the viewer a visual break, allowing them to really focus on the faerie's face.

To make your lines flow, relax your arm when drawing long curves, and use changes of pressure to make the lines appear light at one end and thick at the other. This is valuable for capturing smooth, swooping shapes like the wings or beetle horn.

⊙ As you refine the face, erase the rough sketch lines left over from earlier, to keep the face tidy. Do not rush this stage, and make sure you are using a sharpened or mechanical pencil to achieve clean lines.

⊙ Use strong, confident, straight lines to draw the faerie's wings, and define the inside veins clearly but lightly. Avoid overdoing the veins, as we do not want the wings to become heavy and distracting. Try to limit them to a couple of stylized zigzags.

⊙ Create a floral holder for the lantern by sketching the petals as ovals around the top, then wrapping curved lines around the lantern in a loose fashion to suggest grassy stems. Attach the stems to the swinging lantern tail at the bottom.

⊙ It's useful to add some extra graphite in areas where the thickest lines and darkest shadows will be, to guide you in the inking stage. For example, add some thicker strokes to the faerie's stomach and the underside of her hat.

INKING

When all the pencil lines are in place, you can begin inking the final line art. You can do this on the same sheet of paper, and then carefully erase the pencil lines when the ink is dry. The ink lines should be definitive and confident, but try not to fill out the entire character with ink. Instead, limit the use of solid black to only the darkest shadows. Areas such as the wing membrane textures and lantern light would be better described with color, so save finishing them for the color stage. Avoid using very thick lines when inking bright areas or delicate materials in general. The resulting line work should be clearer and sharper than the sketch phase, but still have some loose, empty areas to define with color in the next step.

⊙ To focus attention on the faerie's face, use a brush pen or thick fineliner to create solid black shadows underneath her hat and hair. Balance these out by using thinner lines to add fine details to the hair, creating an extra layer of value and texture.

⊙ Line thickness is important to consider for overlapping or background elements, such as the wings. Notice how the shoulder is more thickly lined, while the wings behind it have lighter lines to create depth and indicate their lightweight material.

⊙ When adding texture to the dress and leggings, make sure the lines follow the flow of the material. Avoid overdoing the texture here – we need to leave some empty space for color details.

⊙ Add some stylized lines to areas like the skirt to create a more interesting textured effect. Remember that these patterns must be easy to look at, and not too small and fussy, otherwise they will fragment the viewer's attention and become distracting.

COLORING

This is a friendly faerie who is close to nature, and though she is partly inspired by insects, she should not look threatening or unpleasant. You can achieve this by using the colors of leaves, soil, and sunlight, choosing green hues and warm tones that will give her the feeling of being lit by fireflies. Start with the lightest pencils, using gentle marks that barely leave a trace at first, before building up the darker colors and layers of texture.

⊙ Keep the face bright and simple – just one shade of pale orange, with touches of red to highlight her nose and eyelids. You can use blue for the eyes, as this cool color pops out well against the warm palette.

⊙ Use pale orange to color the skin, and a darker tan for the shadowed skin areas. It is more impactful to create large shadow areas instead of many small shadows. For example, the entirety of one arm is in shadow, which gives the faerie's pose depth.

⊙ Use dark brown to color the beetle hat and exoskeleton. Press the colored pencil hard in the dark areas and more gently in light areas, but try to keep the strokes moving in one direction, otherwise the textures can end up messy.

⊙ Use light yellow to color the wing membranes. Leave some areas very pale to make them look thin and transparent, while applying more pressure at areas like the bases and ends to give them structure.

GRIFFIN

BY CARISSA KAYE POWELL

In this tutorial we will be creating a griffin, also known as a griffon or gryphon – a fantastical hybrid creature classically depicted as half eagle, half lion. This griffin will look like a streamlined, agile predator with the head, wings, and talons of a bird of prey, feline hindquarters, and a long tail to help it maneuver in flight. A subtle, naturalistic coloration will give the griffin an element of camouflage, while a contrasting blue color will balance out the brown palette with some more unusual features.

TOOLKIT

- Pencils (red and graphite)
- Black fineliner
- Eraser
- Colored pencils or markers (see page 161 for color palette)

RESEARCH

Griffins are mythical beings, but like most fantasy creatures, the inspiration for them can be found in nature. Before we get started on the griffin, let's research their real-life counterparts: cats and birds. Try sketching a page of feline and bird species. Studying them will enable you to draw a much more convincing griffin. Sketch your animals quickly and loosely until you feel yourself growing comfortable with their anatomy.

EARS > A griffin's ears set them apart from having the head of an ordinary bird. They could be pointed, round, or curled, drawing inspiration from feline anatomy.

HEAD > The front half of the griffin will be birdlike. It could have the stern head of a bird of prey, such as this eagle, or any other bird species if you wish to create something different or more outlandish.

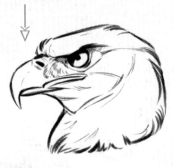

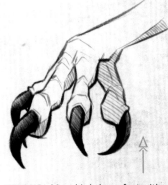

TALONS > Most birds have feet with three digits at the front and one digit at the back. Some, like owls, have two digits in front and two at the back.

WINGS > A griffin typically has birdlike wings, which will need to be appropriately large to support its weight in flight.

PAWS > A griffin's back half is often cat-like, including feline hind legs. These could belong to a large cat like a lion or a small cat like an ocelot.

THUMBNAILS

A strong thumbnail will have diverse shapes, so try to offset large shapes by placing them beside smaller ones. Stay loose and exaggerate proportions – variety and exaggeration will make your thumbnails more interesting. Focusing on round shapes will make your figure appear soft and friendly; square shapes will feel imposing and sturdy; triangular shapes can feel sharp and dangerous.

Thumbnail 6 has a striking silhouette because of its shape variation. The contrast in size between its large front half and slender hindquarters makes it very visually appealing and graceful.

CHOSEN THUMBNAIL

FOUNDATIONS

With your red pencil, lightly sketch the basic form of your thumbnail using simple shapes. This will give your design more clarity. Limit the number of shapes you use, so that the design will be clear and readable from a distance.

Figuring out the griffin's basic geometry will make the final design stronger and more recognizable. Remember your animal research and take anatomy into account, as the griffin needs to be both striking and structurally sound.

BASE

⊙ A griffin needs proportionally large wings compared to a real bird to carry its weight. Sharp wing shapes will make it appear more imposing. Rounder shapes would have a gentler effect.

⊙ Do not worry about connecting the body parts yet. Using an oblong for the head will make it stand out from the triangular forms of the rest of the body.

⊙ Using triangular shapes for the legs will make the design feel less sturdy and balanced than rectangular pillars. This works in the design's favor, as the griffin is more at home in the air than on land.

LINES

⊙ Use the basic geometry as a guide for the rest of the griffin's forms. Add ears and a beak, roughing out the eyes and mouth, and connect the griffin's head to its shoulders with a birdlike neck.

⊙ Sketch the wing by adding curves over the basic geometry, but try to preserve the angular silhouette. Don't forget to add the other wing, set slightly lower than the one in the foreground.

⊙ Give the griffin slender hind legs to draw attention to its larger front half. This will make the design that much more imposing, like a lion.

BUILDING UP

Now that you have an understanding of your griffin's basic geometry, let's begin to really get a feel for its anatomy. When you are sketching, be sure to "draw through" as if your griffin were completely translucent. Draw limbs on the opposite side of the body entirely. This will ensure that the creature's anatomical structure is sound, as it will also help you avoid drawing "floating" limbs that do not seem properly connected at the joints.

◉ Birds appear to have thick necks because of their dense feathers. To give your griffin a similar appearance, give it a lion-like mane of feathers or fur, or a combination of the two.

◉ Add more structure to your griffin's wings. Do not be afraid to erase and resketch areas to improve the anatomy, but keep your strokes loose and do not worry about detail yet.

◉ Your griffin's talons will be its primary weapons. When adding these, recall from the research stage that birds usually have three digits in front of their foot and one at the back.

◉ Continue adding details to the tail if you would like your griffin to have fur or feathers at the end. Keep these forms light and airy so the tail does not feel heavy.

DESIGN FOCUS

FUR AND FEATHERS › The easiest way to draw areas of thick or long fur or plumage is to sketch the overall shape instead of focusing on individual hairs or feathers. Draw enough lines to suggest the texture and the viewer can interpret the rest. The feathers or fur should lie in the same direction as on other animals, flowing downward.

FEET › You can find reference images (or use your own photos from zoo visits!) to help with the feet and talons. When the griffin is standing, make sure it feels like its body weight is really resting on its feet. Keep the claws' tips resting flat on the ground, not curling through it.

WINGS › Bird wings can be tricky. Refer to your research if you need to, and don't get caught up drawing individual feathers yet! Block in curves to indicate the groups of feathers, focusing on anatomy and form. When you draw the feathers later they will feel like uniform parts of a whole.

IDEA INVENTORY

WINGS > Birds have different wing shapes for different types of flight. If your griffin is built for speed, it will have pointed wings like a falcon. Large and broad wings are used for soaring, like eagles do, while long and slender wings are seen in birds that fly over water, like gulls.

The long, gull-like wings will be well suited to the griffin's light, slim shape. ⇒

EARS > Beaks are not very expressive, so ears will drastically improve your griffin's ability to display emotions like curiosity or fury. Ears can also give your griffin a much more recognizable silhouette. Cats offer a wide variety of ear shapes to choose from — or they could be another shape altogether. Feline ears tend to have fur on the inside and often have longer fur near the base.

These long ears are like a lynx's, with tufted tips that give them a distinctive shape.

FINAL SKETCH

Gently erase the basic geometry and parts of the sketch where structures overlap one another or lines appear messy. Redraw the sketch with clean lines and the details you have been waiting until now to add, such as layers of feathers. Lightly add shading to map out where shadows will fall – in this case, mainly under the belly and on the background limbs. Your sketch does not need to be perfect – the goal is to have a clean, detailed sketch to make inking easier. You will not have the luxury of an eraser when inking!

⊙ Imagine the light source is directly above the griffin and the shadows from its body are falling directly beneath it. Shadows will fall under its body and wings, and on the legs farthest away from us.

⊙ Fill in the griffin's wings with individual feathers, but pay close attention to their structure. On the underside of a bird's wing, the curved edge of each feather faces toward the body. On the reverse side, it is the opposite.

⊙ Use long, curved strokes to detail the larger feathers, and a few smaller curves to suggest the presence of shorter feathers without drawing them all in detail.

⊙ The lynx-like ears from the Idea Inventory have a striking height that adds interest to the silhouette, and their angular shape matches the basic geometry of the rest of the design best.

⊙ Finish sketching the griffin's face and add detail to its beak. You may need to use reference photos or rely on your research. I choose to give mine a fierce, stern expression.

INKING

Inking is about tidying up and distilling the sketch into a clear, bold image, rather than continuing to add more details. Do not let the permanence of ink scare you – be confident in your lines! You can either ink and erase the pencil lines once the ink is dry, or you can start afresh with a new sheet of paper by using a lightbox (a drawing surface that can light up paper from underneath). Always test your pens first and make sure they will not smear when you use your coloring tools later.

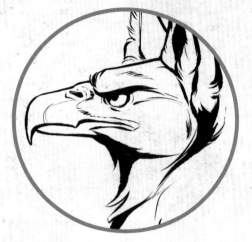

◉ Use different line widths throughout the drawing to make it more dynamic. Drawing with thinner strokes on the top of the griffin and thicker strokes underneath or in shadowed areas will add a sense of form.

◉ It is easy to get carried away drawing the outline of every clump of fur, but too much texture can quickly lead to an incoherent mess of lines. Less is more!

◉ To keep your wings from looking stiff and overworked, try suggesting the smaller feathers instead of completely drawing each one. Using fewer lines keeps your drawing from looking too cluttered.

◉ Block in the darkest shadow areas with large areas of ink to add more depth to the griffin. Just be sure to use these areas sparingly so the drawing does not become too dark.

A natural color palette will make the griffin appear more realistic. Look to birds and cats for reference; they can both have vibrant coloration and markings, but they can be combined so they appear cohesive and match your griffin's environment in a fun, creative way. Do not start with the darkest colors. Instead, start light and work towards the darker colors, building them up slowly so that you do not accidentally make your light areas too dark. A small amount of accent color can make your design stand out. In this case, the griffin's palette is mostly warm brown with a touch of blue.

◉ The griffin's colors do not need to be completely uniform. Subtle markings and changes in color will make your griffin appear more lifelike. Even animals that appear to be a solid color typically have subdued changes in hue.

◉ Begin with the lightest colors first before layering up the darker browns. Note how some areas have soft transitions between them, while the face has crisper contrast to create focus.

◉ Like in nature, parts of the body with lots of contrasting values and markings will stand out as focal points. The griffin's beak, eyes, and front feet are cool blue, and this sudden change in color draws the viewer's attention to those areas.

◉ Animals, especially flying ones, often have a light underbelly and darker back. This is to offset their shadow, so that if you are on the ground looking up, their light belly blends in with the light of the sky.

ORC

BY FRANK WILLIAM

In this tutorial we'll be creating an orc warrior: a hulking fighter with battle scars and dented armor as evidence of his many hard-won victories. In fantasy worlds, orcs are usually depicted as large humanoids, often with green skin and animal-like fangs. We will combine these classic elements with some armor and weapons worthy of a fearsome, respected warrior.

TOOLKIT

- ◉ Graphite pencil

- ◉ Eraser

- ◉ Thick, medium, and fine black fineliner pens

- ◉ Colored markers (see page 171 for color palette)

RESEARCH

This orc will be a barbarian warrior, with his main characteristics being a fearsome facial expression, robust body shape, and heavy, roughly forged metal armor. Begin by studying some possibilities for armor and weapons, and some relevant anatomy. This character will be strong and muscular; his physique may pose some challenges to draw, so it will be useful to plan and practice his anatomy and torso musculature. Sketch with pencil for now, until you understand how the subjects work and how to build them.

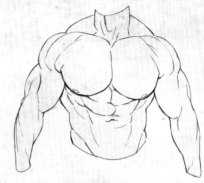

TORSO › This orc's anatomy is essentially that of a strong human, so it is key to study some human anatomy and musculature. When it comes to making the drawing, your lines will be more flowing, accurate, and confident, even if the concept is simplified or stylized.

TASSETS › "Tassets" are plates of armor that protect a warrior's upper thighs, and would be perfect for this character. His tassets could include leather and animal furs; adding other fabrics, metals, and ornaments will make the design much more interesting.

BARBARIAN › Even at this very early stage, it is helpful to visualize all the components the final character might need. Sketching a loose full-body plan of the idea can help to focus your research.

PAULDRON › The orc could wear a pauldron, a piece of plate armor that protects the shoulder. It could be made from distorted metals, animal hide, and even the teeth of some creature. These features help to tell a story by suggesting who the character is and how he lives.

AXE › A large metal weapon such as an axe could help to demonstrate the warrior's strength and power. The weapon's handle could be wrapped with leather to make it look more rugged and sturdy.

THUMBNAILS

Explore silhouette thumbnails using geometric shapes. This orc has a large, strong physique; you can make him look huge and muscular by using a square block for his torso, then complement that shape with smaller triangular elements and points, such as a sword or axe. A wide stance with his arms and feet set apart will make him look tough and resolute.

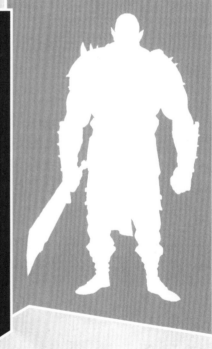

CHOSEN THUMBNAIL

Thumbnail 7 represents the structure of an orc the most effectively, with large shoulders forming a powerful, top-heavy shape. His limbs are clearly silhouetted, giving greater fluidity and strength to the character.

FOUNDATIONS

Start to build the body using basic geometry. For now, do not worry about armor, weapons, and accessories. Use a graphite or colored pencil to sketch out an enlarged version of the chosen thumbnail, drawing lightly and not using much force on the pencil. When you are satisfied with the shapes, use a graphite pencil to start connecting them, fleshing out a definite figure.

BASE

⊙ Give the character a small head to make his body look even more broad and intimidating. There is no need to draw the neck yet – just a rectangular shape to indicate the head is enough.

⊙ The torso is square and wider than the average human torso to give a feeling of brute strength. Block in the pelvis as a rectangle. Avoid increasing the length of the legs too much, as that would make the character look more slender.

⊙ Use cylindrical forms to give the orc's limbs a humanoid shape. The arms should come down to around mid-thigh, and are about the same thickness as his legs to give him an immense, powerful build.

LINES

⊙ At this part of the process, do not worry about details. The important thing is organizing the main elements of the orc's body and indicating basic anatomical landmarks. Use diagonal strokes to indicate his collarbones, and some simple curves for his pectoral muscles.

⊙ Add curved contours to the limbs to give them volume, and to indicate protruding joints like the knees and elbows. You may find it helpful to look at reference photos online, or at your own arms and legs in a mirror, to decide how the limbs curve and twist.

⊙ Continue using geometric shapes for the construction of the face, working with angular lines for better control of the orc's anatomy. Block out his heavy brows and serious mouth, the underside of his nose, and the rough shape of his beard extending below the head.

BUILDING UP

Now that the orc's largest basic shapes have been established, you can begin adding the medium-sized details: clothes, armor, and muscles. These should adhere to the proposed structure of the original thumbnail. Keep using a graphite pencil for this stage, but apply a little more pressure to give the character more definition.

⊙ The features of an orc are robust: thick eyebrows, a broad nose, and tusks coming out of the mouth, all accompanied by a scowling expression. Add a vertical line to indicate the bridge of his nose, making it crooked to suggest that it has been broken in the past.

⊙ When drawing the armor on the shoulders and forearms, use straight lines and smooth, unbroken curves to indicate the rigidity of the metal, and raise it slightly above the orc's body to give the plates thickness.

⊙ Triangular elements make the design more interesting and bring greater complexity to a blocky character, even during this basic stage.

⊙ Draw the fabric with smooth, flowing lines to suggest a hanging material. It is important to consider how you draw each material, so your lines clearly convey what these elements are made from.

⊙ Use geometric forms to outline the armor, leather, and fabrics in a simple but solidly constructed way. For example, use halved cylinders for the forearm armor, and add blunted cones to them to create the spiked studs.

DESIGN FOCUS

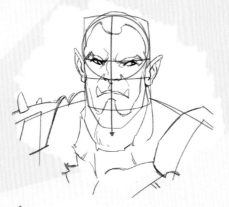

HEAD > Before drawing the beard, you should map out the character's face to make sure that the beard will be in proportion. Start the face by making a circle, and divide it with a vertical line and horizontal eye-line. Below the circle, place another horizontal guide for the nose and ears, and block out the jaw, which is larger and heavier than a typical human's. The brows and mouth should also be broad and angular.

ARMOR > When drawing the shoulder armor, make sure the upper plate sits slightly higher than the lower plate, so it looks like the two plates are overlapping. This armor is quite rustic and roughly made, so the forms do not have to be very smooth and rounded.

BOOTS > Add wrinkles and folds to the orc's leather boots using soft zigzagging lines and angular edges. This indicates that the material is sturdy and worn, but somewhat soft. Avoid adding too many wrinkles and folds though, or the leather will look like a loose fabric.

IDEA INVENTORY

WEAPONS > When exploring different types and shapes of weapon for the character, think about how these would influence the design. For example, a very small weapon does not match the personality of a huge, hulking orc warrior. Instead, heavy, unrefined weapons provide a more appropriate sense of power.

Out of these options, the rough, rectangular blade is the best. It looks plain and weathered, but fierce and effective, with a blocky shape that matches its owner.

ARMOR > The same approach goes for the shoulder plates. A decorative, polished look is more common among noble characters, such as knights, but for this warrior, the better option for an orc would be a plain, dented shoulder plate.

This orc would wear the simplest shoulder armor, padded with animal fur and decorated with the teeth of a defeated creature.

FINAL SKETCH

Lightly erase the initial guidelines with a putty eraser and start cleaning up the final details of the character in pencil. Use this stage to define everything you would not feel confident drawing directly in the ink. The goal is to have everything in place, clean and tidy, so that you can ink the drawing without being afraid of making mistakes or realizing that something could have been improved earlier in the process.

⊙ To add the character's sword, imagine the rectangular blade viewed at an angle, so it is tilted into a rhombus shape instead of being a flat oblong. Make sure the character's fingers are clearly grasped around the weapon's handle — you can look at your own fist to help with this.

⊙ At this stage, add details of the muscles we studied during the research stage. These do not need to be deeply detailed, but they should be defined clearly enough to give the character a feeling of strength and brute force.

⊙ When drawing the animal furs, use lightweight strokes, curves, and "S" shapes to create a soft, flowing fur texture.

⊙ Seams, patches, and bindings can help to convey the feeling of a heavily worn outfit made from weathered materials. Use these elements sparingly so they do not become distracting. In this case, add the extra details to the boots and legs.

INKING

Now that the drawing is clean and defined, you can begin inking the final line art. You can do this on the same sheet of paper, then carefully erase the excess pencil lines when the ink is dry, or if you have a lightbox, you can use that to make the line art on a new sheet of paper. To avoid any unpleasant surprises, always test your materials on a separate piece of paper to make sure they are compatible with each other. Working calmly and carefully is fundamental at this stage.

⊙ When inking the clothes and muscles, make the lines darker and thicker where the forms are shaded from the light, such as the undersides of cloth folds. This gives depth to the drawing by suggesting some shadows.

⊙ Use your thinnest fineliner to add grooves and scratches to the armor, using diagonal and curved strokes to make the metal look worn. If these lines are too straight, they can end up looking weird and flat!

⊙ The inner lines of the drawing should be more fine and subtle, while the outlines should be heavier, so that there is a clear and visually interesting contrast of information.

⊙ As well as adding shadows to the outer contours, you can add some interior shadows and solid black areas. These should not be overused, as we will be adding more depth with colors next, but areas like the belt holes and shadows beneath the boots can be added now.

COLORING

To color the drawing, use the tools you prefer or feel the most confident with, but if you are working with markers, it is important to use a separate paper to test all the colors and how they overlap first. A limited palette of sober colors will give seriousness to the character. To give the final image some realism, aim to make the different materials and textures of the clothes and armor clearly distinguishable from each other by varying the colors and highlighting.

⊙ The armor is old and weathered, and therefore less reflective than new, polished armor. To create this effect, shade the armor evenly and do not leave very strong highlights. Limit the bright highlights to the animal teeth and light metal edges of the armor to make those details stand out.

⊙ Cheeks, ears, and elbows have a greater flow of blood, so these regions should be more reddish, but do not over-apply this – the effect should be very subtle. Apply some red to the orc's scars as well, to make them stand out against his green skin.

⊙ The fabrics and fur would be shabby and worn, so add patches and layers of gray and brown to build up the feeling of dirt and constant use in battle.

⊙ Color the skin by applying an even layer of light green, then building up more layers with the same color to add definition to the shadows. Finally, use a restrained amount of light brown to add variation to the darker areas, and to create the heaviest shadows.

PROJECT BRIEFS

If you need some more ideas for drawings of your own, this is a perfect place to begin. Here you will find a treasure trove of ideas for fantasy characters and creatures, including a few pointers for their histories and appearances, which you can use as a quick springboard for your own research and sketches. Use the skills you have picked up from this book's tutorials and see what exciting interpretations you can come up with!

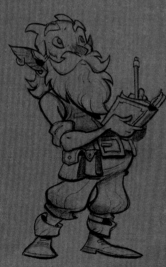

Image © Martin J. Abel

ENCHANTED WARRIOR

This character is a seasoned fighter who protects her land with a combination of magic and martial skill. She is tall with curly hair, a confident stance, and noticeable scars from a past battle.

WINGED HORSE

This rare horse is not only fast and graceful on land, but a marvel in the air! Its feathery wings are large enough to lift it effortlessly off the ground, and nobody has tamed it yet.

AQUATIC DRAGON

Sometimes seen resting on cliffs and beaches, this unusual reptile uses its wings and talons for diving and catching fish. The local fishermen are not certain whether it can breathe fire.

WEALTHY TRADER

This jovial merchant is a popular figure in the bustling trading port. He has an ornate beard and a paunchy stomach from his love of wine, and likes to wear the latest colorful fashions from abroad.

DWARF ALCHEMIST

This dwarf is the first in his family to put down the hammer and blacksmith's apron, and pursue a passion for potion-making. Protective gloves and goggles are essential!

ELF SORCERESS

This wise elder is well-versed in healing spells and the keeping of magical plants. She wears her hair in two long plaits and carries a staff cut from the branch of an enchanted tree.

GOBLIN MERCHANT

This pioneering little merchant ventures above ground more frequently than other goblins, bringing magical carvings and rare potions that are some of the best in the land.

BANISHED FAERIE

This wicked, scruffy faerie was banished from her kingdom for causing too much mischief. Now she hides in bushes and trees, waiting to torment innocent passersby with her traps.

FAERIE KNIGHT

Tiny but fearsome and widely respected, this knight is one of the most celebrated members of the faerie queen's entourage, wearing splendid armor and a cloak of rare feathers.

COURT JESTER

This jester has entertained the king for years with jokes and sleight-of-hand tricks. He wears a jester's cap and bells on his shoes. The other servants sometimes wonder if he knows a bit of real magic.

DISGRACED NOBLEMAN

Once the head of a powerful and wealthy family, this man has since fallen on hard times. He is thin and bedraggled, with a bitter temper and expaensive clothes in need of repair.

GLOSSARY

Analogous colors

On the color wheel, analogous colors are colors that sit directly next to each other and create a harmonious color scheme. For example, green, yellow-green, and yellow create an analogous palette.

Complementary colors

On the color wheel, complementary colors are two colors that sit directly opposite each other and create a contrasting color scheme. For example, orange and blue are a pair of complementary colors.

Contrast

In art, contrast refers to the differences between parts of an image. It could refer to the contrast between large and small shapes, bright lights and dark shadows, or different colors. Contrast can be used to create **focal points** and **visual interest**.

Focal point

An image's focal point is where the viewer will look first – the area that is the most interesting and impactful. This is often an area with high detail and contrast, such as a character's face.

Heraldry

Heraldry is a broad term referring to visual devices such as "coats of arms," which you might see on banners and shields. Knights, families, and institutions throughout history have used heraldic designs to identify themselves.

Highlight

An image's highlights are its brightest areas, which would be shaded with the lightest colors. For example, these might be the areas that have the shiniest material, or are closest to the light source.

Hue

Hue refers to the basic category of a color – for example, whether it is green, yellow, or red. Changing the value of a hue would result in a lighter or darker color, such as dark red or light blue.

Line of action

In drawing, a line of action can be visualized as a line that flows through a figure, usually along its spine, indicating a strong sense of movement or direction. A character with a distinct, flowing line of action will look dynamic and exciting.

Line weight

A line's weight refers to its thickness or thinness. A drawing with lines that change weight will often look more fluid and interesting than one that has the same line weight throughout.

Mass

In art, if a shape has mass, its conveys size, weight, and three-dimensional form. See also **volume**.

Midtone

An image's midtones are the tones in between the highlights and shadows. For example, in a grayscale image, the midtones would encompass most of the shades of gray in between black and white.

Rendering

In drawing and painting, rendering refers to the process of fleshing out an image with shading, color, and texture.

Shape language

In concept design, a drawing's "shape language" refers to how geometry is used to convey different meanings. For example, a character with a soft, round shape language will come across differently from a character with a pointed, angular shape language.

Value

In art, a color's values refer to its qualities of lightness or darkness, or whiteness or blackness. An image with high **contrast** will contain extreme differences in value, while an image with low contrast will not feature many different values.

Visual interest

This phrase refers broadly to creating an engaging experience for the viewer of your image. You could create visual interest with an eye-catching color, for example, or by using contrast or texture.

Volume

In art, if a subject has volume, it has a sense of three-dimensional depth. This can be achieved with shading and perspective.

Image © Martin J. Abel

CONTRIBUTORS

Martin J. Abel

Martin is a fantasy artist based in Tasmania, Australia. He has created work for *Crystal Clans*, *ImagineFX*, and *Official Xbox Magazine*, as well as publishing his own art books.
martinabelart.com

Johan Egerkrans

Johan is a Stockholm-based concept artist, illustrator, and writer with over 20 years' experience in publishing, games, and films. His own books include *Vaesen*, *Norse Gods* and *The Undead*. (Photo credit: Ida Sundqvist)
egerkrans.com

Roma Gewska

Roma is an illustrator based in Kyiv, Ukraine, who is inspired by fantasy roleplaying games, Slavic myths, spooky stuff, and witty puns. She tries to give a unique personality, story, and outfit to every character she designs.
artstation.com/gewska

Maria Wejs Henriksen

Maria is a Danish character animator who branched out as an illustrator. She now works on her passion projects as a freelance creature and animal illustrator.
artstation.com/mariahenrik

Marion Kivits

Marion is a freelance concept artist and illustrator based in Belgium. Studios she has worked for include Volta, Atelier 801, WayForward Technologies, and Solid Clouds.
artstation.com/marionkivits

Carissa Kaye Powell

Carissa is a freelance artist based in Los Angeles, California. Originally from Texas, she enjoys character design and draws inspiration from the beauty of the American Southwest and its inhabitants.
simkaye.com

Valentina Remenar

Valentina is an illustrator and concept artist based in Slovenia. She has created work for clients including DeviantArt, *ImagineFX*, Celsys, and Amnesty International.
valentinaremenar.com

Leon Ropeter

Leon is a concept designer and artist from Hamburg, Germany. He is passionate about creating concepts and illustrations for games and movies – especially designing characters.
artstation.com/chewlon

Audre "Charamath" Schutte

Audre is a creature concept artist and illustrator who works freelance in the Pacific Northwest area of the United States.
charamath.com

Khoa Tran Viet

Khoa is a freelance concept artist who loves fantasy art and is currently based in Ho Chi Minh City, Vietnam.
artstation.com/vietkhoa

Frank William

Frank has been working as a teacher and illustrator for over five years, creating concepts and artwork for card games, board games, and books.
artstation.com/frankwilliam

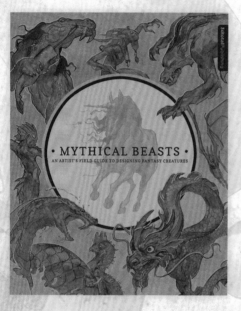

3dtotalPublishing

MYTHICAL BEASTS

Join thirty fearless artists as they explore and develop concepts for a treasure trove of fascinating mythical beasts. Each creature has its own chapter that covers an overview of its history, how to detail main elements such as fur and horns, and the thought process behind the artist's design. A spellbinding anthology for fantasy lovers, creature artists, or any intrepid adventurer looking to investigate the enchanting world of cryptozoology. Discover the exciting world of creature design!

BEGINNER'S GUIDE TO SKETCHING: ROBOTS, VEHICLES & SCI-FI CONCEPTS

Pick up your pens and pencils and join talented professional artists in this invaluable introduction to sketching quintessential sci-fi subjects such as spaceships, robots, futuristic vehicles, and innovative buildings.

Background image © Ang Chen

SKETCHING FROM THE IMAGINATION

In each book of the *Sketching from the Imagination* series, 50 talented traditional and digital artists have been chosen to share their sketchbooks and discuss the reasons behind their design decisions. Visually stunning collections packed full of useful tips, these books offer inspiration for everyone.

THE SKETCH ENCYCLOPEDIA

A fascinating art resource showing you how to draw over 900 people, places, creatures, and objects.

3dtotalPublishing

3dtotal Publishing is a trailblazing, creative publisher specializing in inspirational and educational resources for artists.

Our titles feature top industry professionals from around the globe who share their experience in skillfully written step-by-step tutorials and fascinating, detailed guides. Illustrated throughout with stunning artwork, these best-selling publications offer creative insight, expert advice, and essential motivation. Fans of digital art will enjoy our comprehensive volumes covering Adobe Photoshop, Procreate, and Blender, as well as our superb titles based around character design, including *Fundamentals of Character Design* and *Creating Characters for the Entertainment Industry*. The dedicated, high-quality blend of instruction and inspiration also extends to traditional art. Titles covering a range of techniques, genres, and abilities allow your creativity to flourish while building essential skills.

Well-established within the industry, we now offer over 100 titles and counting, many of which have been translated into multiple languages around the world. With something for every artist, we are proud to say that our books offer the 3dtotal package:

LEARN ○ CREATE ○ SHARE

Visit us at 3dtotalpublishing.com

3dtotal Publishing is an offspring of 3dtotal.com, a leading website for CG artists founded by Tom Greenway in 1999.